Starley Talbott

IMAGES
of America

PLATTE COUNTY

IMAGES
of America

PLATTE COUNTY

Starley Talbott

ARCADIA
PUBLISHING

Published by Arcadia Publishing
Charleston SC, Chicago IL, Portsmouth NH, San Francisco CA

Printed in the United States of America

Library of Congress Control Number: 2009921916

For all general information contact Arcadia Publishing at:
Telephone 843-853-2070
Fax 843-853-0044
E-mail sales@arcadiapublishing.com
For customer service and orders:
Toll-Free 1-888-313-2665

Visit us on the Internet at www.arcadiapublishing.com

To the memory of my parents, Harry and Alma Dayton, who loved the Wyoming prairie and lived the pioneer life.

CONTENTS

ACKNOWLEDGMENTS

Many people provided support for this book, and it could not have been completed without their help. Members of the Platte County Historical Society, the Chugwater Historical Unity Group, Slater Women's Club, and the Laramie Peak Museum contributed generously. It is impossible to include the photographs and history of many deserving families who were Platte County pioneers. Important resources for my work are the stories published in the 1981 book *Platte County Heritage*. I am grateful to the staff at the Platte County Library, especially Ruth Vaughn, Libby Mickelsen, and Lee Miller. A special thank you goes to Donald Britton at the Wheatland Irrigation District and the staff of the Wheatland Rural Electric Association. My appreciation goes to Milo Dawson of the Wyoming National Guard Museum and to the staff of the Wyoming State Archives, Department of Parks and Cultural Resources, especially to Suzi Taylor, reference archivist, and Robin Everett, receptionist.

So many individuals provided photographs and information it would be difficult to list them all, but special thanks go to Darrell and Marian Offe of Hartville; Betty Amick and Janette Chambers of Glendo; Rick Robbins, Jerry Orr, Elvira Call, Neil Kafka, Linda Fabian, and Fred and Mickey McGuire of Wheatland; and Lindy Schroeder and John Voight of Chugwater. I also wish to thank my editor at Arcadia Publishing, Kelly Reed, for her support and guidance, and my husband, Beauford Thompson, for his encouragement.

INTRODUCTION

For centuries, the vast windswept prairies of the territory that would eventually be called Wyoming were known only to herds of bison, elk, deer, antelope, and other animals. The only humans to inhabit the area prior to the 1800s were Native Americans. Except for fur trappers and traders, a few ranchers, and miners, the non-native people who traveled through Wyoming territory in the 1800s did not give the area more than a passing glance. Thousands of immigrants traveling by covered wagon left their mark on the land in the form of deeply carved wagon wheel ruts. Those ruts are still visible in several places in Platte County. Immigrant names were also carved in stone at Register Cliff, near the present town of Guernsey, Wyoming.

The arid, sagebrush-covered land did not interest those bound for the lush farmlands of Oregon and California or the goldfields of California, Nevada, Montana, and the Black Hills. Not until the late 1800s were the southeastern plains of Wyoming territory considered fit for human settlement. When Wyoming became a territory in 1869, there were five counties extending the full length from north to south. They were Uinta, Sweetwater, Carbon, Albany, and Laramie. With the coming of the railroad in 1869 and the formation of the state of Wyoming in 1890, settlers began to put down permanent roots. In 1911, Goshen and Platte Counties were carved from a portion of Laramie County.

Before the railroad arrived, the Overland Stage Route and the Cheyenne-to-Deadwood Stage Route passed through the area that would become Platte County on a path similar to the modern-day route of Interstate 25. The U.S. government opened a road and erected a telegraph line in 1867 between Fort Laramie and Fort D. A. Russell in Cheyenne. Several roadhouses and stage stops were located along the routes, including Little Bear, Chugwater Station, Bordeaux, Eagle's Nest, Uva, Cottonwood, and Horseshoe.

The great cattle industry of southern Wyoming reached its peak in the 1880s. The vast Swan Land and Cattle Company was headquartered in Chugwater. The company controlled millions of acres on which they ran thousands of head of cattle and sheep.

The formation of the Wheatland Development Company and an irrigation project to bring water from the Laramie River to the Wheatland Flats caused an upsurge of settlement in the Wheatland area. The town of Wheatland began in 1894, was incorporated in 1905, and became the seat of Platte County when the county was formed in 1911. The area that comprised the Wheatland Flats covers about 20 miles between the Laramie Mountains on the west and Chugwater Creek on the east and about 22 miles from the Laramie River on the north to the Richeau Hills to the south. According to historians, it took the imagination of a poet, Johnny Gordon, the vision of a politician, Joseph M. Carey, and the tenacity of a good businessman, Andrew Gilchrist, to transform the cactus-covered plains into a valuable irrigation district.

Johnny Gordon moved to Wheatland from Greeley, Colorado, in 1878, after he had discussed the possibility of an irrigation project with Judge Joseph M. Carey on a visit to Carey's ranch. Judge Carey was impressed with the idea and organized a committee in Cheyenne to finalize

plans for the project during the winter of 1882. Work was begun that year on a tunnel to divert water from the Laramie River to Blue Grass and Sybille Creeks and on to the Wheatland Flats. Canals were also constructed to carry the water to the proposed farmlands. In 1883, the Wyoming Development Company was formed to oversee the project. The company had control of the land through the allocation of water rights, and settlers, under the Desert Land Law, took up the acreages. The Wyoming Development Company eventually became the Wheatland Irrigation District, a private company that still operates to this day.

Wheatland has remained an important hub for farming and ranching into the present time. The Missouri Basin Power Project's Laramie River Station was completed in 1980, providing electric power to two million residents in eight states and providing a major source of employment in Platte County.

Dozens of small towns sprang up throughout the area in support of the large farming community that developed in Platte County. The remaining viable towns are Chugwater, Glendo, Guernsey, Hartville, and Wheatland. Hartville claims to be the oldest incorporated town in Wyoming. It was a rowdy frontier town that has retained its western flavor and is home to Wyoming's oldest bar. Sunrise was a company town operated by the Colorado Fuel and Iron Company containing many large brick buildings, including the first YMCA built in Wyoming. The only remaining traces of Sunrise are on private property. Guernsey was a stopping place for Oregon Trail travelers; became a town following the completion of the Chicago, Burlington, and Quincy Railroad Line; and is now the location of the Wyoming National Guard training facility. Guernsey Dam and Guernsey State Park are popular areas, as are nearby historical sites, including the Oregon Trail Ruts National Landmark and Register Cliff. Glendo was a way station for Oregon and Overland Trail followers and stagecoach travelers. It later became a well-known water recreational area after the completion of Glendo Dam in 1959. Chugwater was the headquarters for the Swan Land and Cattle Company and a hub for ranchers and farmers in the southern portion of Platte County. Today Chugwater retains its historical flavor with several businesses, including the oldest continuously operated soda fountain in Wyoming.

Though Platte County remains a quiet place and an area that travelers sometimes continue to pass by as they whiz along the black ribbon of highway that intersects the county, it contains a wealth of spirited people who find it a pleasant place to call home.

One

WATER, LIFEBLOOD

OF THE LAND

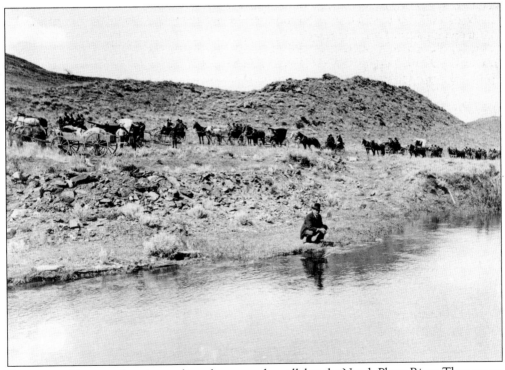

A caravan of home seekers is traveling along a road parallel to the North Platte River. They are on their way to take up land in the Wheatland Colony in the late 1800s. (Courtesy of the J. E. Stimson Collection, Wyoming State Archives, Department of State Parks and Cultural Resources.)

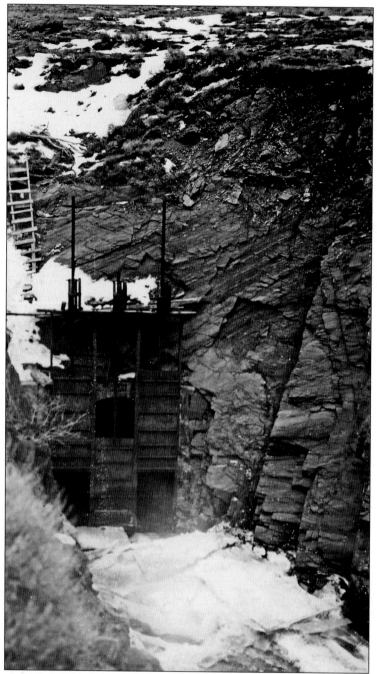

Work was started in 1883 on an irrigation project that would transfer water from the Laramie River through a series of canals and deliver it to the Wheatland area. This project allowed farmers taking up land near Wheatland to irrigate their farms. This photograph shows water gushing through the inlet gates of the 3,300-foot diversion tunnel that brought water from the Laramie River into Blue Grass Creek. The water then flowed into Sybille Creek and through a series of canals that carried it into the Wheatland community. The tunnel was drilled through solid rock and was completed in 1886. (Courtesy of the Wheatland Irrigation District.)

Canals No. One and No. Two were begun in 1886. Canal No. One was 34 miles long, and Canal No. Two was 10 miles long. Teams of men and horses were used in the early construction phase of the irrigation project. Improvements were made to the canals over a period of years. Though many hardships were encountered during the years of construction, the project was not abandoned, and work continued to bring water to the farmlands around Wheatland. (Both, courtesy of the Wheatland Irrigation District.)

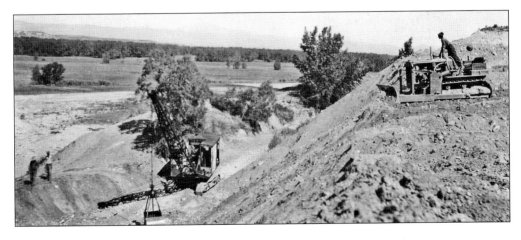

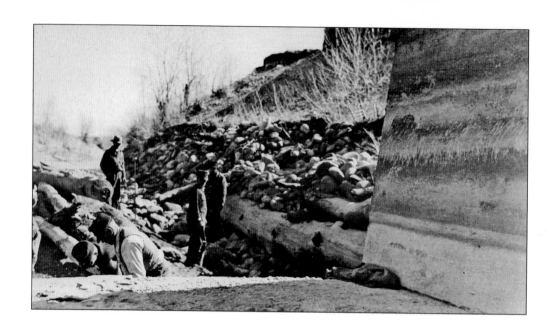

A large cement structure was put in at the beginning of Canal No. One. Heavy steel gates were installed to hold the water back until needed. This enabled the irrigation company to control the flow of water through the canal. (Both, courtesy of the Wheatland Irrigation District.)

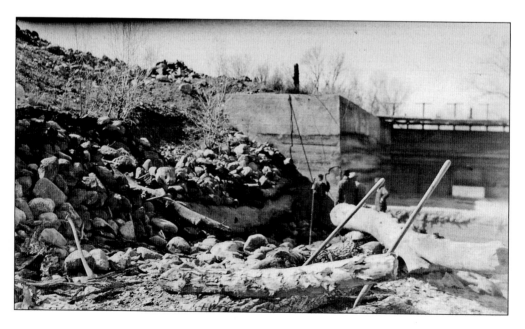

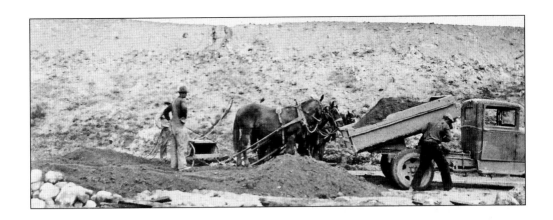

As the farms in the Wheatland Colony increased in number, the need for additional irrigation water in the months of July, August, and September was established. Canal No. Three was constructed to divert water to storage reservoirs. The canal was constructed with the help of both horse and machine power. (Both, courtesy of the Wheatland Irrigation District.)

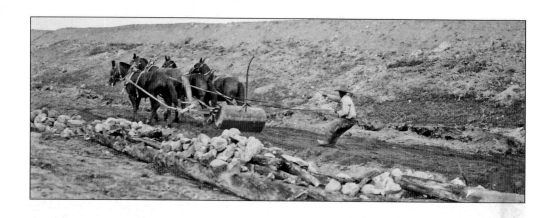

The photograph above shows a man driving a team of horses to clear the land for Canal No. Three. The photograph below shows men working on the canal with shovels. A large contingent of men was needed to complete the construction on the canals and reservoirs. The workers were a "wild and motley crew of laborers in the grading and construction camps," according to accounts of the day. One of the first settlers who established a farm in the irrigation district was Caldwell Morrison, whose wife, Esther, was hired to cook for the construction crew. It was reported that Esther baked as many as 70 loaves of bread a day for the workmen. (Both, courtesy of the Wheatland Irrigation District.)

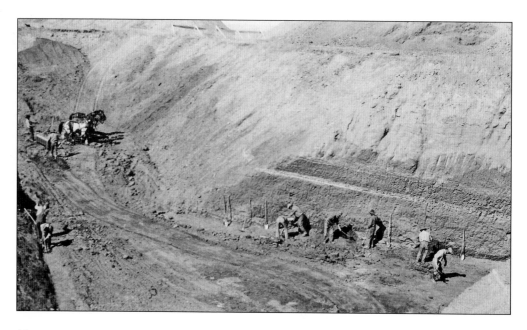

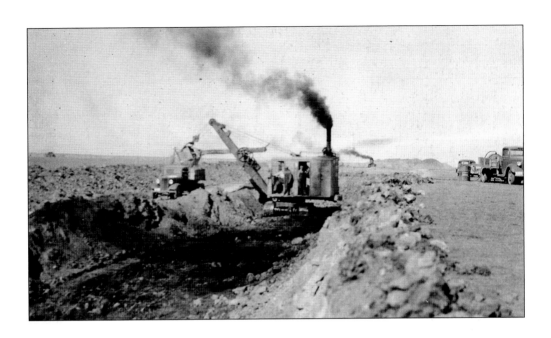

Smoke rises from the engines of machinery used to construct Canal No. Three. The power of men, horses, and machines helped to complete the project. Farmers who had planted their crops in the new irrigation district were pleased with the results of the project. One of the first settlers in Wheatland Colony was William Ayers, who wrote to the Wheatland Development Company on February 14, 1913, stating, "My original land purchase was 80 acres. I have increased my holdings since that time, until I now have over six hundred acres, all of which I have paid for by farming and stock raising, having been in debt when I located in Wheatland. . . . Any man who will attend to business and will farm properly will succeed in the Wheatland Colony." (Both, courtesy of the Wheatland Irrigation District.)

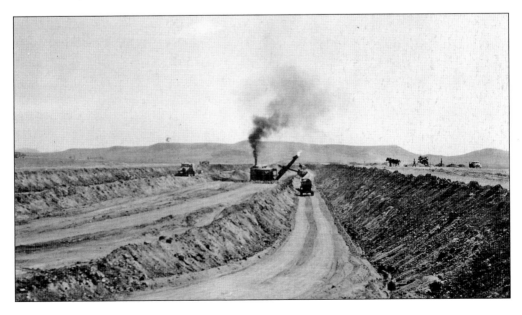

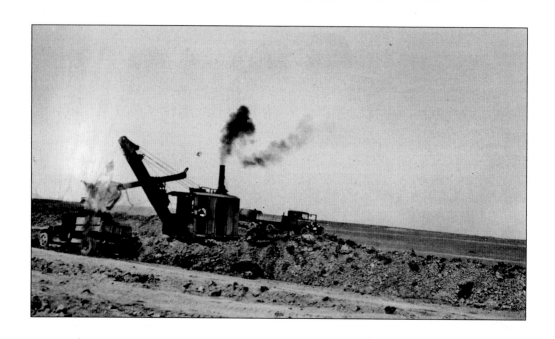

A steam shovel was used to remove dirt from Canal No. Three. During construction, ridges of rock had been encountered that had to be blasted with dynamite so the steam shovels could handle the work. When the canal was completed, it brought water to be stored in a new reservoir. (Both, courtesy of the Wheatland Irrigation District.)

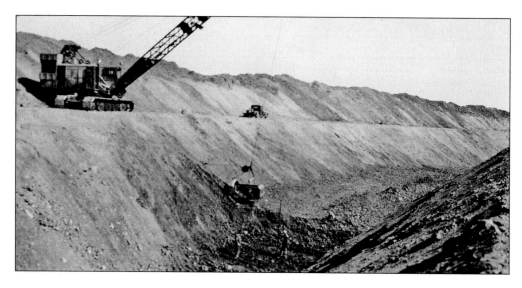

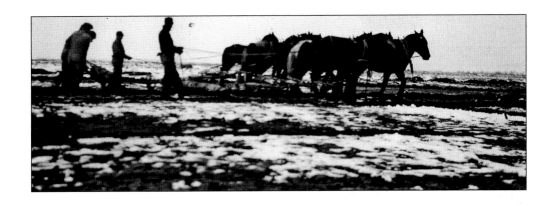

Additional water storage capacity was acquired by the construction of Reservoir No. One. Early construction is shown here; teams of horses level the land needed for the reservoir. The early reservoir was designed to hold 5,280 acre-feet of water. The Wheatland Development Company promoted the irrigation system in a brochure, stating in part, "To fortify against drought in any season, the system embraces reservoirs for the impounding of water during the flood period. It has been shown that the reservoirs are of sufficient magnitude to conserve water for the irrigation of all lands in the project." (Both, courtesy of the Wheatland Irrigation District.)

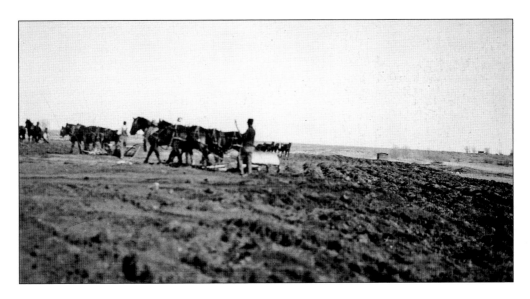

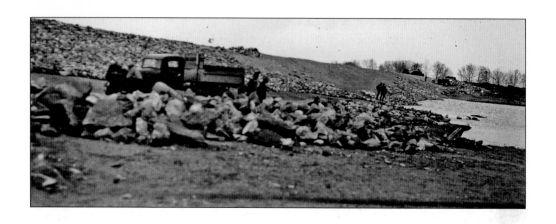

A few years after the original construction, enlargements were made to Reservoir No. One. The photograph above shows trucks being used to haul dirt and rocks for the construction project. Throughout the years, improvements and enlargements were made to Reservoir No. One. The storage capacity was eventually brought up to 9,369 acre-feet of water. (Both, courtesy of the Wheatland Irrigation District.)

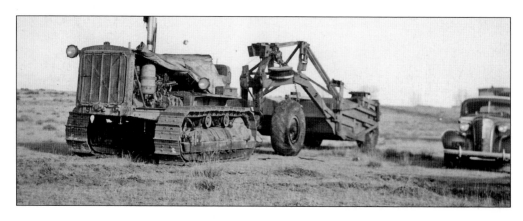

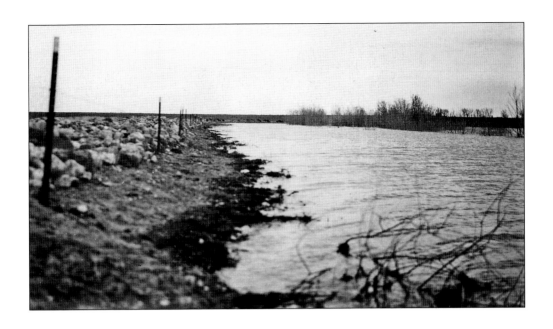

These photographs show Reservoir No. One with a shoreline of 4 miles. Requirements for Reservoirs No. One and No. Two called for excavation at the bottom of each basin. Each reservoir was to have a buildup on the sides forming an earth-filled dam with rock facings. (Both, courtesy of the Wheatland Irrigation District.)

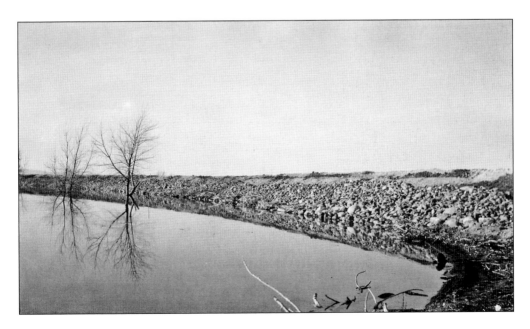

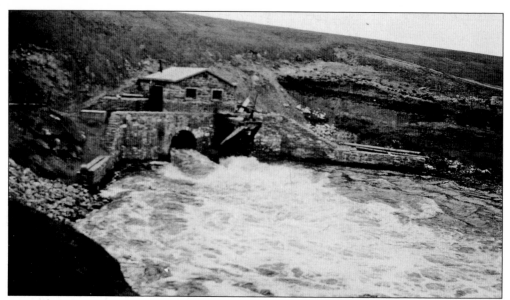

It was soon discovered that an additional reservoir was needed to store water, leading to the construction of Reservoir No. Two. This photograph shows water flowing into Reservoir No. Two. The reservoir covers 6,000 acres of land and has a shoreline of 39 miles. It holds 98,000 acre-feet of water. (Courtesy of the Wheatland Irrigation District.)

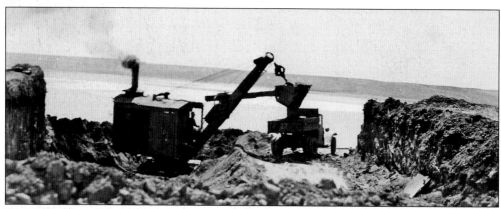

During the drought and Depression years of the 1930s, the Wheatland project was declared a drought disaster area. There had been considerable silting occurring in Reservoir No. Two, and it needed additional excavation work. A WPA project removed about 500,000 cubic yards of earth and rock, which was used for raising and widening the dam. Some 25 teams of horses, a dozen trucks, two steam shovels, and a dragline were used during the improvement project. (Courtesy of the Wheatland Irrigation District.)

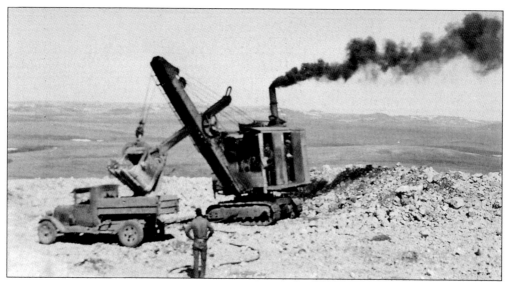

This steam shovel loaded dirt onto a truck during improvements to Reservoir No. Two. In 1901, the Wyoming Development Company relinquished some rights to the irrigation project to the Wheatland Industrial Company. Both companies administered the project for the next 46 years. In 1947, the entire system, which had cost more than $1 million, was signed over to the newly created Wheatland Irrigation District for the sum of $1. The district assumed responsibility for maintaining and operating the project. Additional improvements were made over the years, and the district still operates as a private company serving 850 users with approximately 54,000 acres of irrigated lands. (Courtesy of the Wheatland Irrigation District.)

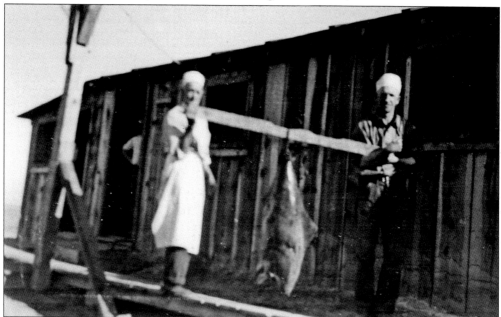

When hundreds of WPA workers helped reconstruct Reservoir No. Two, they stayed in temporary camps and ate at the field cookhouse. These two cooks display large fish that came from the reservoir and were used to feed the crew during the 1930s. No fishing is allowed in the reservoir today. (Courtesy of the Wheatland Irrigation District.)

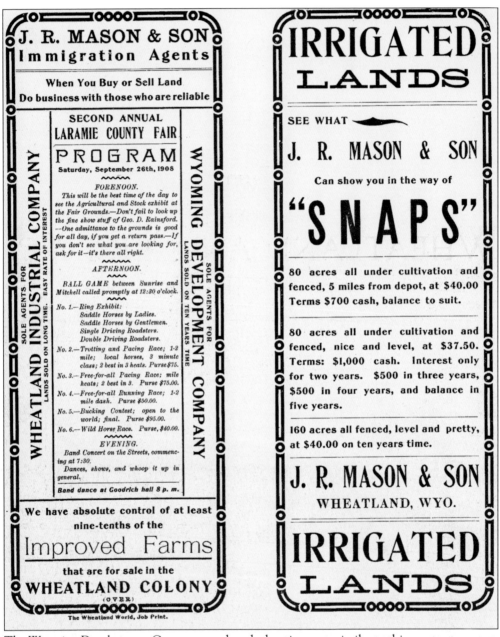

The Wyoming Development Company produced advertisements similar to this one to encourage people to move to the Wheatland area and begin farming there. The company boasted that the pioneer days of the Wheatland Colony were over. "In its place you will find a first-class system of schools, telephone, rural mail delivery, churches, railroad facilities, and in fact every convenience offered by the farming districts of the Eastern States," the literature exclaimed. The company printed its prospectus in German as well as English in an effort to appeal to the tide of emigrants arriving from Germany. (Courtesy of the Wheatland Irrigation District.)

Two

WHEATLAND AND VICINITY

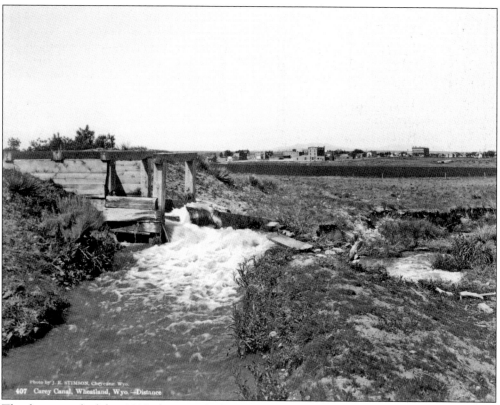

The foreground of this 1903 photograph shows water flowing through an irrigation ditch. The water system was said to symbolically represent the circulatory system of the town. The growing town of Wheatland is seen in the background. (Courtesy of the J. E. Stimson Collection, Wyoming State Archives, Department of State Parks and Cultural Resources.)

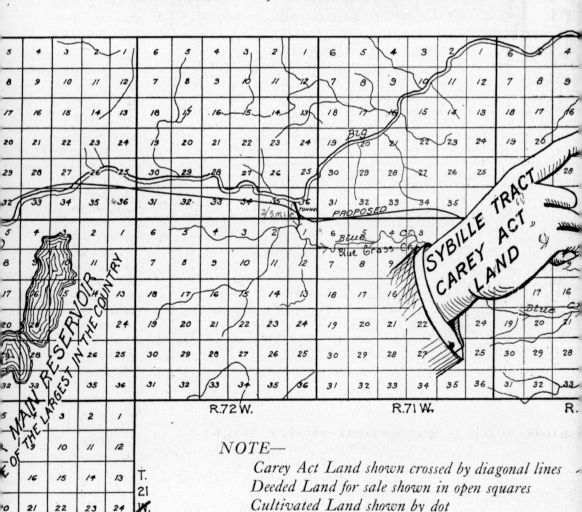

NOTE—

Carey Act Land shown crossed by diagonal lines
Deeded Land for sale shown in open squares
Cultivated Land shown by dot

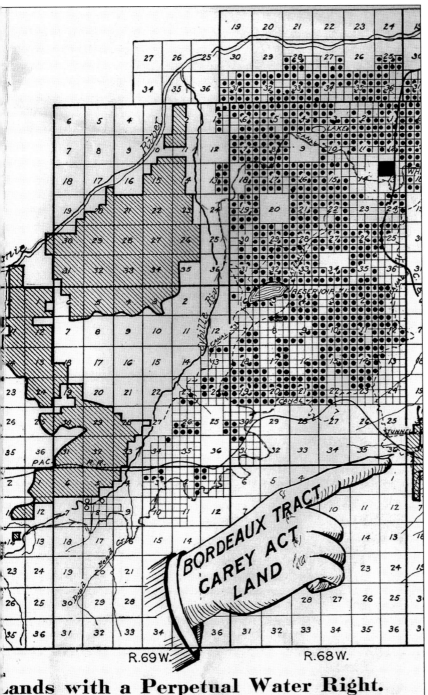

This map shows the lands that were to be irrigated by the Wyoming Development Company. The company did not own the land, only the water rights. Homesteaders had to acquire the land through the Carey Desert Entry Act, which allowed anyone over 21 years of age to claim 640 acres of land. The Carey Act required application of water to the land to obtain a patent. When proof was made, the settler received a patent for the land directly from the State of Wyoming, and when full payment was made for the water right, a deed was issued. Only about one-fourth of the Bordeaux tract was developed and cultivated. The Sybille tract was never developed. (Courtesy of the Wheatland Irrigation District.)

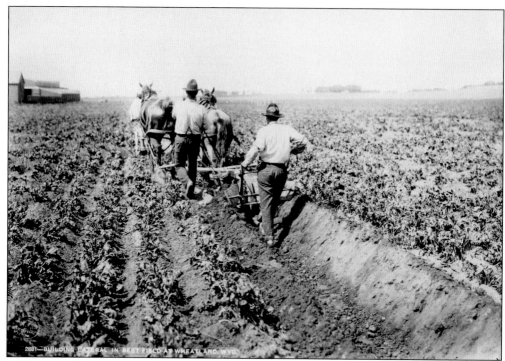

Approximately 60,000 acres of land around the town of Wheatland were included in the Wheatland Development project. This photograph shows how some of the new farmers plowed a ditch with a team of horses to bring water from an irrigation canal to their acreage. (Courtesy of the J. E. Stimson Collection, Wyoming State Archives, Department of State Parks and Cultural Resources.)

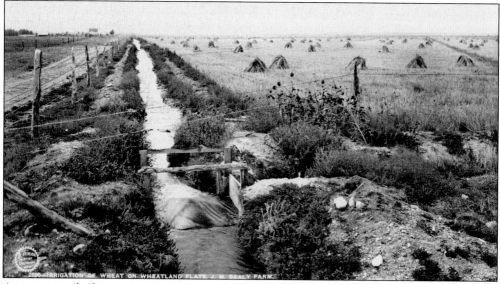

An irrigation ditch carries water to the newly developed farmlands around Wheatland. The crops grown in the early years included hay, wheat, barley, oats, corn, and beans. Irrigation ditches also ran through the town of Wheatland, supplying water for gardens and trees. (Courtesy of the J. E. Stimson Collection, Wyoming State Archives, Department of State Parks and Cultural Resources.)

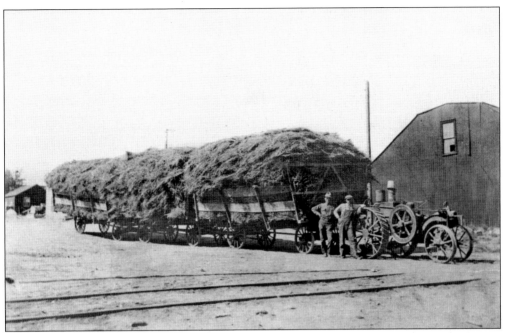

One of the early and profitable crops in the Wheatland area was alfalfa. Alfalfa yields of 3 to 5 tons to the acre were noted in some records. This photograph shows farmers Fred Searle (left) and Byron McGee hauling hay to an alfalfa mill in Wheatland in 1917. The first alfalfa mill was built in 1916 and had a capacity of 5,000 tons of alfalfa meal a year. Another mill was established in 1923. (Courtesy of the Platte County Library.)

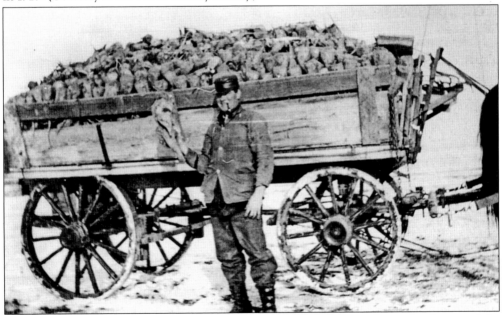

The Wyoming Development Company literature boasted that "a crop destined to be one of the greatest wealth producers of the Colony is the sugar beet." In 1910, one of the pioneer settlers, W. L. Ayers, grew some sugar beets on an experimental basis. Sugar beets were grown commercially in 1911 and for many years thereafter. (Courtesy of the Platte County Library.)

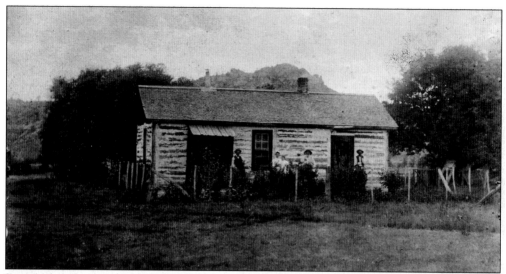

Even before the immigrants arrived in droves to develop their farms around Wheatland, there were a few ranchers established in the area. Duncan Grant arrived in Wyoming territory in the early 1870s and worked a short time as a freighter. He then went to work for the Swan Land and Cattle Company, which owned thousands of acres of land in Wyoming, and was soon named foreman of the Two Bar Ranch on Sybille Creek. Duncan Grant filed on his own homestead in 1874 and built this log home. (Courtesy of Fred and Mickey McGuire.)

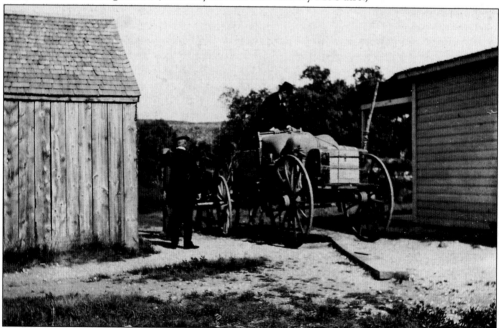

In 1892, Duncan Grant married Mary Elizabeth Regan, a rural schoolteacher. The couple ranched west of Wheatland where they raised four children. Over the years, they purchased additional land, and they acquired acreage from the Two Bar Ranch, which possessed the earliest water right on Sybille Creek. The ranch is presently owned and operated by a granddaughter and her husband, Fred and Mickey McGuire. Duncan Grant is hauling supplies to his ranch west of Wheatland in this photograph. (Courtesy of Fred and Mickey McGuire.)

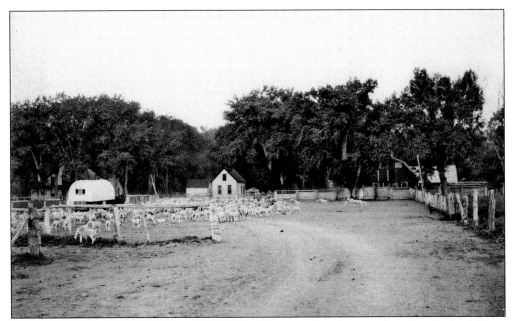

The home buildings of the Two Bar Ranch are shown in this photograph with a flock of sheep. The Swan Land and Cattle Company owned the Two Bar, which was on Sybille Creek in the area that became the western part of Platte County. The Two Bar Post Office was established at the ranch in 1891 with Duncan Grant as postmaster. There was also an Owen Post Office, which moved from ranch to ranch in the western part of the county. The Two Bar and Owen Post Offices closed in the early 1900s. (Courtesy of the J. E. Stimson Collection, Wyoming State Archives, Department of State Parks and Cultural Resources.)

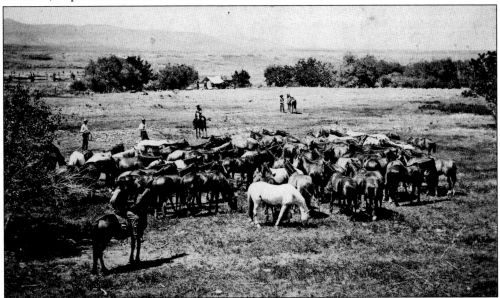

Many cowboys worked for the vast Swan Land and Cattle Company. The ranch kept a large herd of horses from which the cowboys selected their mounts for each day's work riding the range. This photograph shows the cavvy (a band of horses) on the Two Bar Ranch in the late 1800s. (Courtesy of Fred and Mickey McGuire.)

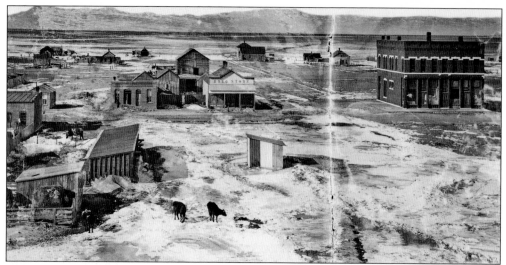

In 1894, the Wheatland town site was laid out, lots were sold, and buildings and improvements followed. Charles C. Goodrich established a brickyard, and many of the first buildings in Wheatland were constructed of locally made brick. His firm supplied 400,000 bricks in 1894 and 750,000 bricks in 1895 for building projects in the community. The two-story brick building in this photograph is the Carey Building on the corner of Ninth and Maple Streets, which today is the location of the Landmark Bar. (Courtesy of Rick Robbins.)

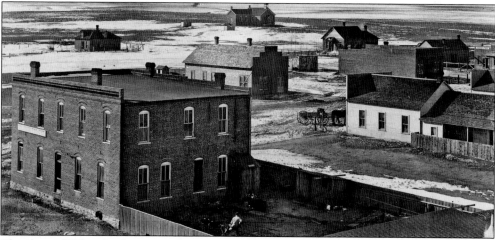

The town of Wheatland continued to grow, and several more brick buildings were constructed. The two-story brick building in the foreground was the Globe Hotel, constructed in 1897. To the right of the Globe Hotel was the building occupied by Wheatland's first newspaper, the *Wheatland World*. Across the street was the Stewart Brothers Bank, built in 1897. (Courtesy of Rick Robbins.)

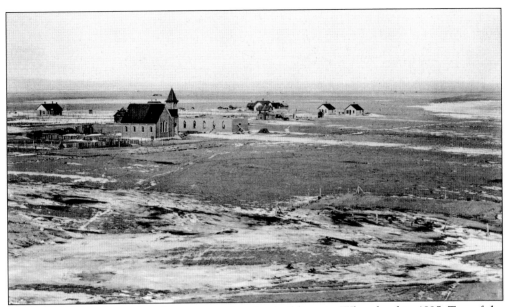

This photograph shows that there were only a few buildings in Wheatland in 1895. Two of the earliest churches are shown in the background. The church on the left with the steeple is the First Methodist Church. The building to the right is the new construction for St. Patrick's Catholic Church. Both churches are still active and in the same locations in Wheatland on Ninth Street. (Courtesy of the J. E. Stimson Collection, Wyoming State Archives, Department of State Parks and Cultural Resources.)

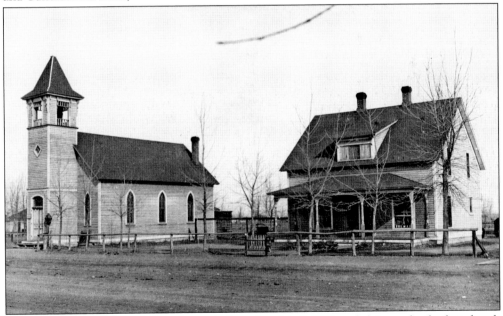

The Union Congregational Church was dedicated on July 7, 1895, and claims to be the first church constructed in Wheatland. The church and parsonage are shown in this early photograph. In 1956, the Union Congregational Church merged with the Evangelical and Reformed Church and was renamed the United Church of Christ. (Courtesy of the J. E. Stimson Collection, Wyoming State Archives, Department of State Parks and Cultural Resources.)

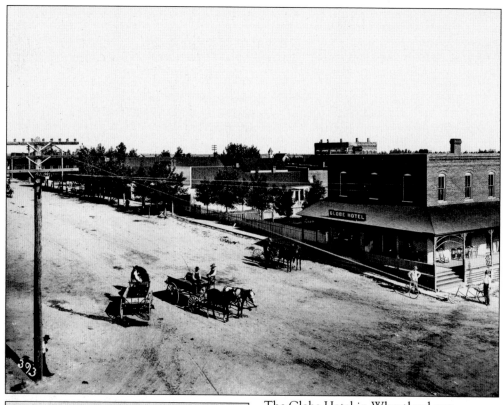

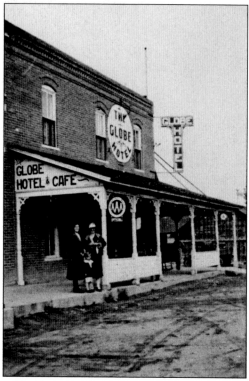

The Globe Hotel in Wheatland was known as "the finest hotel north of Cheyenne." It was built in 1895 of brick manufactured in Wheatland from the Goodrich Brickyard. The street scene above shows a team and wagon driving down Gilchrist Street in front of the Globe Hotel. Several people are shown on the front porch of the hotel at left. (Both, courtesy of the Platte County Library.)

The Globe Hotel continued to be a popular stop for travelers when automobiles brought visitors to Wheatland. It remained a prominent landmark in Wheatland for many years. However, the building was torn down, and all that remains is a mural of the Globe Hotel on the sidewall of an adjacent building. (Courtesy of the Platte County Library.)

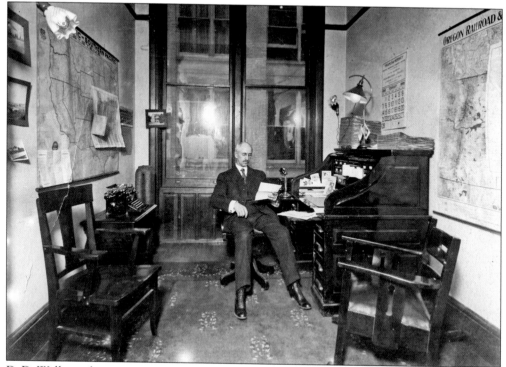

D. D. Wallace, the owner of the Globe Hotel, is shown in the hotel office in 1895. (Courtesy of the Laramie Peak Museum, from the Dorothy and LeGrande Page Collection.)

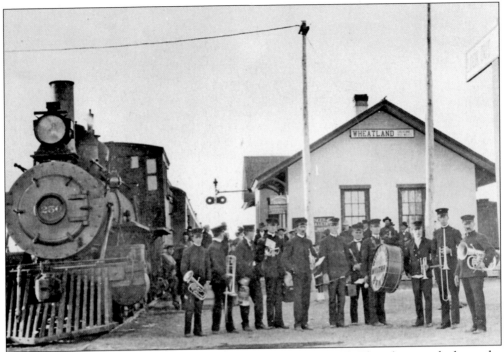

The railroad line into Wheatland was completed in January 1895. This photograph shows the Wheatland band with a steam engine at the depot. It is not known for what celebration the band played. The band was organized in June 1895 and played for ball games, dances, concerts, fairs, parades, and visiting dignitaries. (Courtesy of Jerry Orr.)

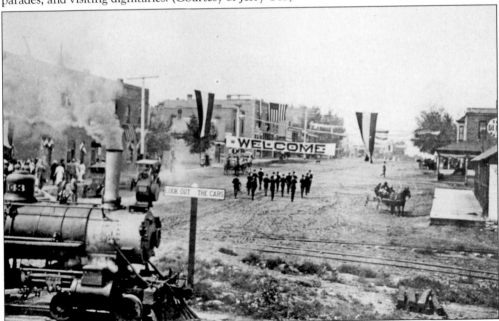

An unknown celebration in Wheatland, probably around 1895, included a performance by the Wheatland band. The band was connected with the Wyoming Militia and was thus often referred to as the Wheatland Military Band. (Courtesy of Jerry Orr.)

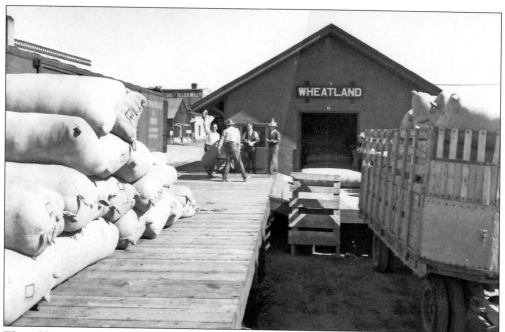

The addition of the railroad and depot was a boon for Wheatland-area farmers and ranchers. Thousands of pounds of wool were sheared each year from the many sheep raised in Platte County. This photograph shows wool growers delivering huge sacks of wool to the depot in Wheatland for shipment to processing plants. (Courtesy of the Platte County Library.)

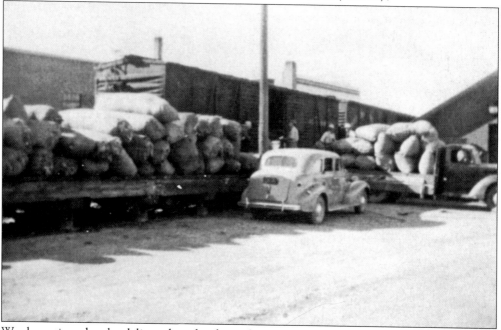

Wool continued to be delivered to the depot for many years because sheep were a profitable business for many Platte County growers. The Woody May family delivered wool to the depot in their 1938 Ford truck during World War II. The May family operated a cattle and sheep operation near Wheatland. (Courtesy of the Platte County Library.)

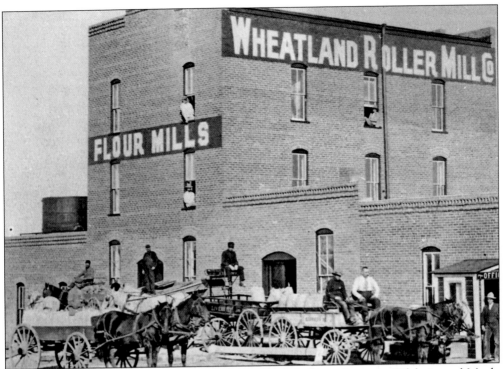

The Wheatland Roller Mill was built in 1897 on Eighth Street between Gilchrist and Maple Streets. Charles Goodrich constructed the mill from locally manufactured bricks at a cost of around $19,000. The mill produced white flour, corn meal, and rye flour and also processed mixed feed and grain. James R. Boyer was the first general manager of the company. (Courtesy of the Platte County Library.)

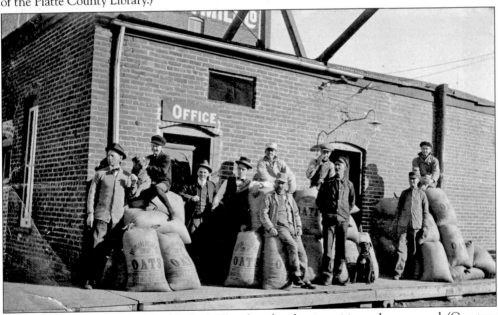

Men stand outside the Wheatland Roller Mill with sacks of grain waiting to be processed. (Courtesy of the Platte County Library.)

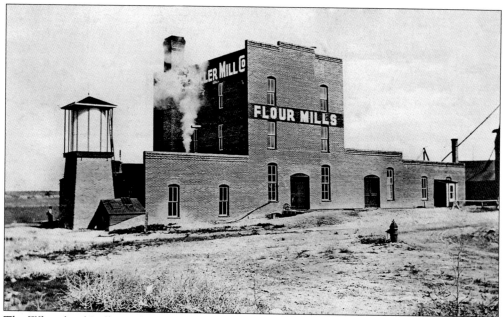

The Wheatland Roller Mill continued to operate for many years. Flour produced at the mill won a gold medal at the 1904 World's Fair in St. Louis. (Courtesy of the Platte County Library.)

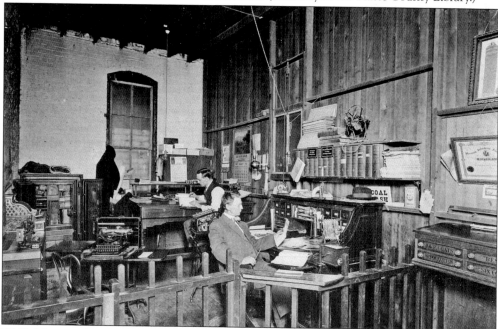

W. H. Morrison became the general manager of the Wheatland Roller Mill some time in the early 1900s. He is shown at his desk in the foreground of this photograph around 1911. A promotional pamphlet for the mill stated, "Our Royal Patent Flour is made from the choicest hard winter and hard spring wheat, carefully selected by our experienced buyer. It is ground in the finest and most modern mill in the world, by an expert miller, who has spent a lifetime at the trade. . . . The bread will be the healthiest, most nutritious bread that can be produced." (Courtesy of the Platte County Library and the Laramie Peak Museum.)

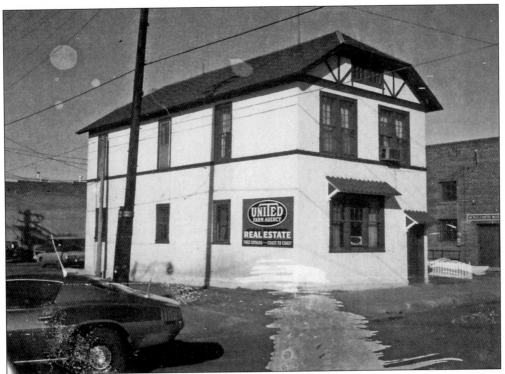

The office of the Wheatland Development Company was the first building constructed in Wheatland in 1894. It was originally on the northwest corner of Ninth and Gilchrist Streets. The building served many purposes besides those of the Wheatland Development Company. There were living quarters for the manager in the back, there were hotel rooms upstairs, and the building served as Wheatland's first post office. It was later moved a half block to the west, the location shown in this photograph. The building still stands and is occupied by a private business. (Courtesy of the Platte County Library.)

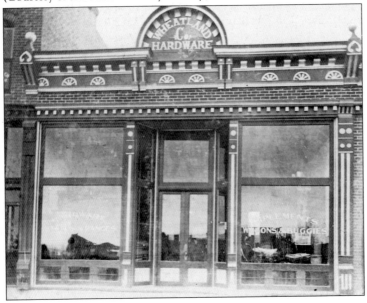

The Wheatland Hardware store on Gilchrist Street operated from 1912 to around 1932. The building still stands and was operated by many other owners over the years. It is now the home of the Wheatland Mercantile. (Courtesy of the Platte County Library.)

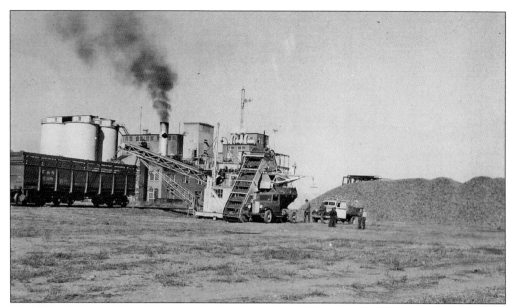

The Great Western Sugar Company built a factory near Wheatland in 1929. Farmers took their beets to various beet dumps to load them onto railcars that delivered the produce to the factory. The factory only operated for a few years due to the complete collapse of farm prices in the 1930s. (Courtesy of the Wheatland Irrigation District.)

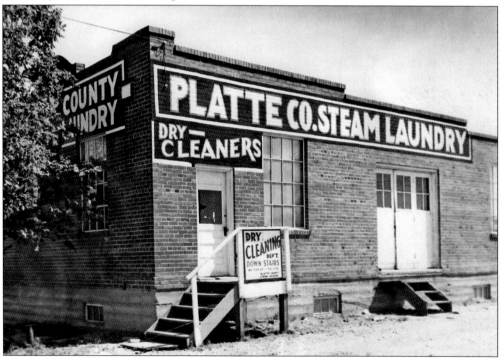

The Platte County Steam Laundry occupied this brick building, constructed in 1927. It was originally part of the Grease Spot system, and bulk oil was stored in vats in the basement. The building was used by many different businesses over the years and still stands on Eighth Street. (Courtesy of the Platte County Library.)

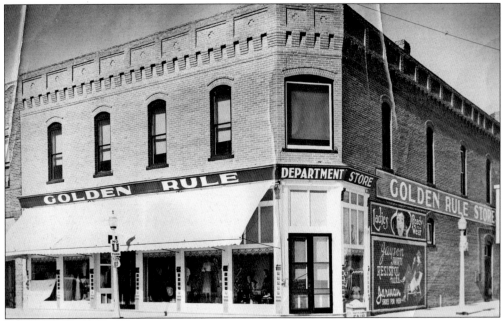

The Golden Rule Store stood on the southwest corner of Ninth and Gilchrist Streets and was a popular department store in Wheatland for more than 40 years. D. "Dad" Miller and Son were the first owners of the building from 1902 to 1918. Their enterprise included a full general store featuring hardware, furniture, and groceries. The store then passed through several owners, becoming the Golden Rule Store in 1937. It burned down on January 11, 1980. (Courtesy of the Platte County Library.)

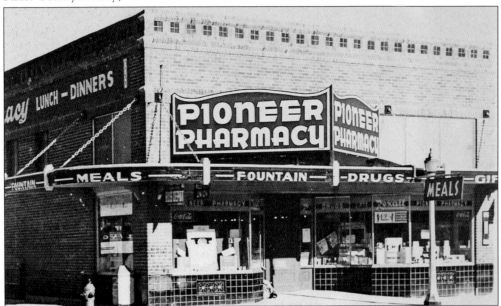

The Pioneer Pharmacy occupied several locations in Wheatland after its beginning in 1896. The pharmacy was located on the northwest corner of Ninth and Gilchrist Streets in 1932 and remained in business there through the mid-20th century. This was the original site of the Wyoming Development Company Building. (Courtesy of the Platte County Library.)

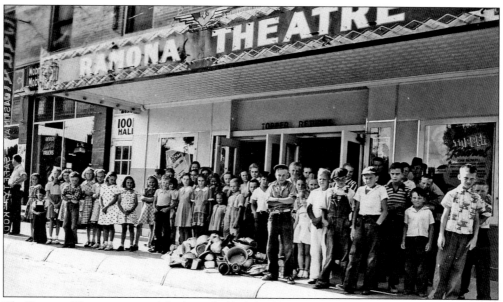

The Ramona Theatre occupied the lower half of a building constructed in 1914 on the north side of Gilchrist Street between Ninth and Tenth Streets. The IOOF Hall was located above the theater, and the Park to Park Garage was to the left of the Ramona Theatre. Frank Webster first operated the theater in the Carey Building and then moved it to the new location. Children are shown in front of the theater, perhaps in the 1940s to 1950s. (Courtesy of the Platte County Library.)

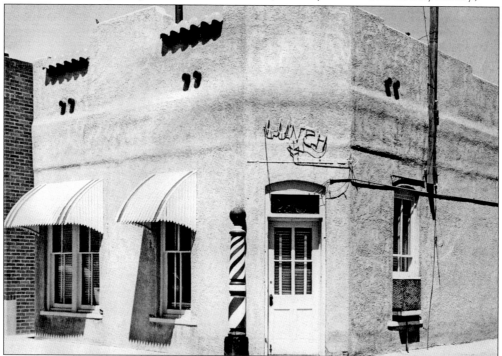

In the early spring of 1895, Charlie Stevens opened a barbershop at 710 Ninth Street. The business later became Waitman's Barber Shop. A lunch counter and pool hall were also located in the building. (Courtesy of the Platte County Library.)

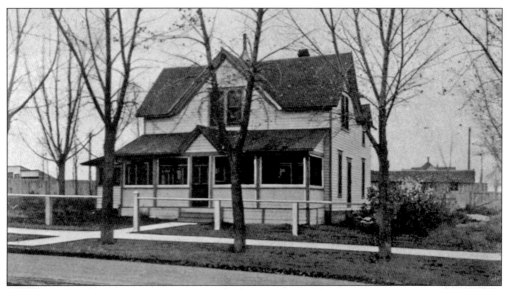

The first hospital in Wheatland was established in 1905 in the home of Dr. F. W. and Margaret Phifer. The hospital had two rooms for patients, a small operating room heated by a wood stove, and a tiny cubicle for the nurse. There was no electricity at the time and no piped-in water. Dr. Phifer originally relocated to Wheatland in search of a healthy location and found that the town offered "a splendid climate and suitable altitude." (Courtesy of the Platte County Library.)

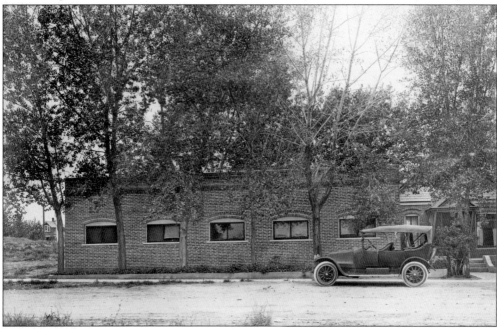

By 1912, the hospital was moved to a new brick building on the northwest corner of Ninth and Water Streets. The hospital also served as a regional clinic and in 1919 treated more than 6,000 outpatients. The hospital continued to add to the staff, and the building was renovated many times over the years. Rates charged in 1920 averaged from $20 to $50 per week. The present Platte County Memorial Hospital was built in 1955 on Fourteenth Street. (Courtesy of the J. E. Stimson Collection, Wyoming State Archives, Department of State Parks and Cultural Resources.)

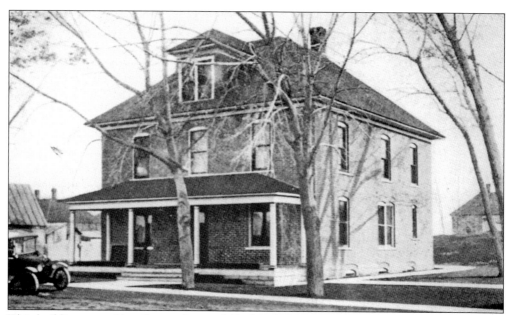

This building served briefly as a hospital. It then became a training school and residence for nurses. It was just west of the home of Dr. David Rigdon, who practiced in Wheatland from 1908 to 1912. The training school was operated by the Wheatland Hospital from 1916 to 1931. Approximately 160 nurses graduated from the program, which offered a three-year course of study corresponding to the requirements of the American Hospital Association. (Courtesy of the Platte County Library.)

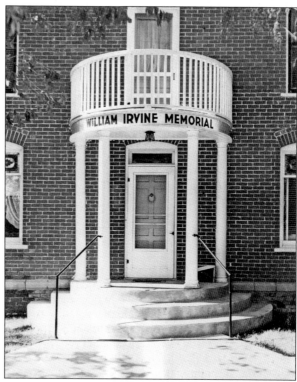

The nurse training school later became the William Irvine Home for men. The building still remains today. (Courtesy of the Platte County Library.)

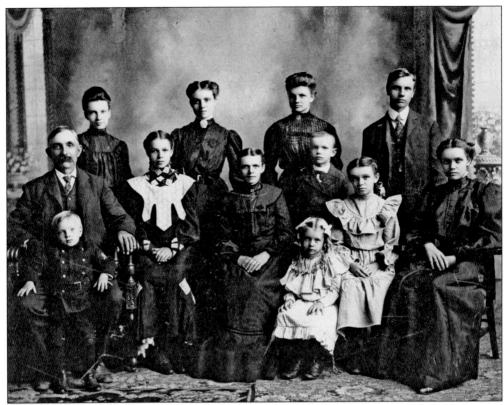

The Frederich "Fritz" Drube family became prominent citizens of Wheatland, moving there in 1911. The Drube family members are, from left to right, (first row) Ernest and Lydia; (second row) Frederich "Fritz" Sr., Augusta, Wilhelmina, Carrie, and Emma; (third row) Ida, Minnie, Rosa, George, and Frederich "Fritz" Jr. (Courtesy of Ronald Swan.)

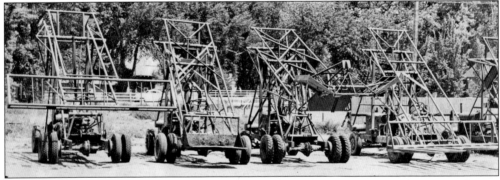

George Drube operated Drube's Machine and Iron Works shop in Wheatland where both Fritz Sr. and Fritz Jr. worked. George died in 1922, and several years later, Fritz Jr. opened the Drube Machine Shop on Sixteenth Street. He purchased the original patent for a self-propelled hay stacker from A. M. Downey of Glendo. Fritz improved on the original patent and built his stacker with a cable. The Drube hay stackers, shown in this photograph, were manufactured in the Wheatland shop and marketed all over the West. (Courtesy of the Platte County Library.)

The Drube sisters, (from left to right) Emma, Carrie, and Augusta, are wearing their fancy hats for an unknown occasion in 1912. Augusta wrote that the sisters and their brother, Fritz, often attended dances around the county. Augusta met her future husband, Oscar Swan, at one of those country dances. (Courtesy of Ronald Swan.)

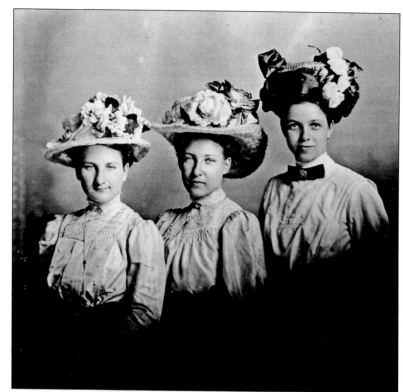

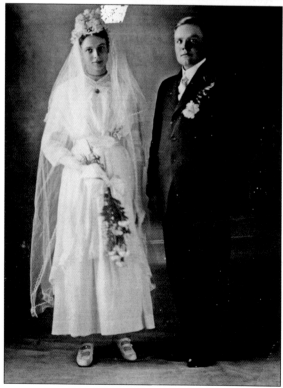

Augusta Drube married Oscar Swan on March 5, 1916. Augusta and Oscar each filed on homesteads in the Antelope Gap community east of Wheatland, where they raised three children: Walter, Alice, and Dean. They grew wheat, oats, and corn on their dryland farm. Augusta wrote that life was difficult, but that all the people in the Antelope Gap community were like one big family. (Courtesy of Ronald Swan.)

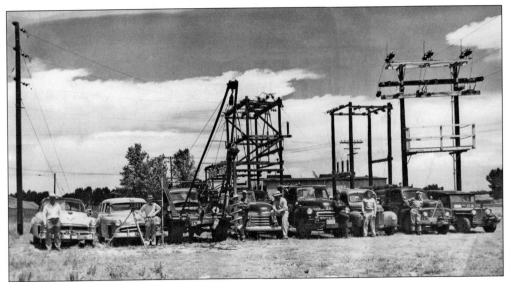

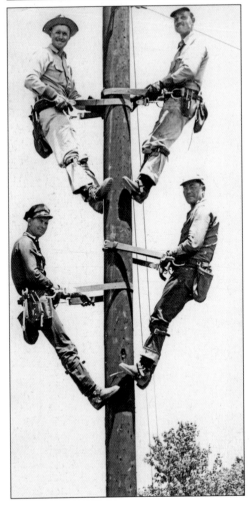

The Wheatland Rural Electric Association (REA) was incorporated in 1936, the same year the National REA Act was passed by Congress. The Wheatland crew began stringing electric lines to the rural areas of Platte County soon after the association was formed. Eventually there were 13 substations and 3 switchyards owned by the Wheatland REA. Workers who helped to maintain these facilities are shown in this 1952 photograph. From left to right are Ward Goodrich, Jack Cole, Deck Robbins, Bill Qualls, Herb Merbach, and Glen Ott. (Courtesy of the Wheatland REA.)

The Wheatland REA pole climbers in this 1954 photograph are, from left to right from the top, Herb Merbach, Glen Ott, Bud Johnson, and Deck Robbins. These men were experts at climbing tall poles to keep the electricity flowing to customers. (Courtesy of the Wheatland REA.)

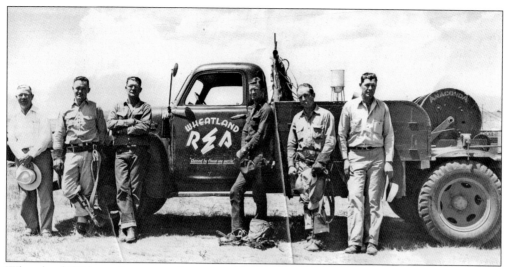

Wheatland REA employees are shown in 1954 standing next to a company truck. From left to right are Ward Goodrich, Herb Merbach, Deck Robbins, Bud Johnson, Glen Ott, and Bill Qualls. Ward Goodrich served as the manager of the Wheatland REA for many years, never receiving a salary until 1951. (Courtesy of the Wheatland REA.)

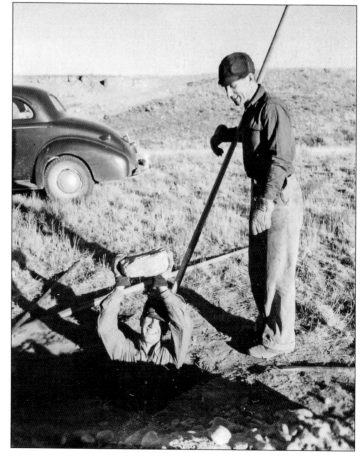

Coop Waters, in the hole, and Percy Turner, with a spoon, show how holes were dug for electrical poles in the 1940s. All holes at that time were dug by hand, and the poles were set by hand using pike poles. The tools used to dig 5- and 6-foot-deep holes were a long-handled shovel, commonly called a banjo; another long handled shovel with a bent blade to pull the dirt out of the hole, called a spoon; an 8-foot steel digging bar; and a short-handled shovel. (Courtesy of the Wheatland REA.)

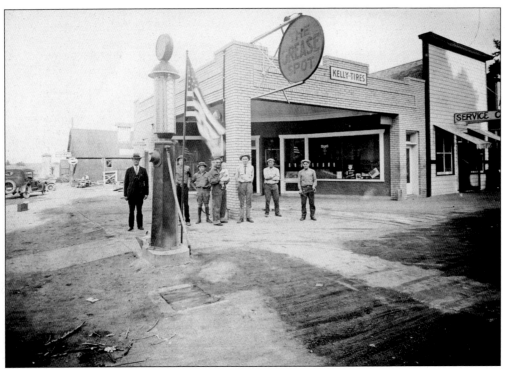

When automobile traffic increased, the Grease Spot Garage was a well-known stop on U.S. Highway 87 through the main business district of Wheatland. The Grease Spot was located on the southeast corner of Maple and Ninth Streets. (Courtesy of the Platte County Library.)

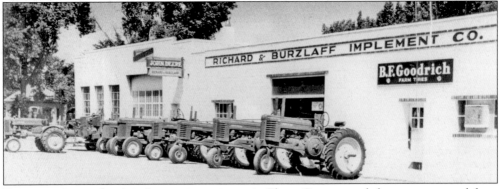

Farming continued to be of major importance in Platte County, and there were several farm implement dealers in Wheatland. This photograph shows a long line of John Deere tractors parked in front of the Richard and Burzlaff Implement Company in the 1950s. (Courtesy of the Platte County Library.)

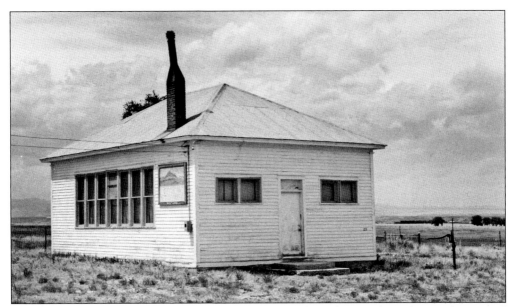

There were many rural schools throughout Platte County from the time the earliest settlers arrived in the area. One of those was the Fairview School, about 3 miles northeast of Wheatland. Fairview School was in existence from 1910 until around 1944. Usually one teacher was employed in a rural school and taught students from grades one through eight. The Fairview School building was sold in 1981 to a private party and was torn down for the lumber. (Courtesy of the Platte County Library.)

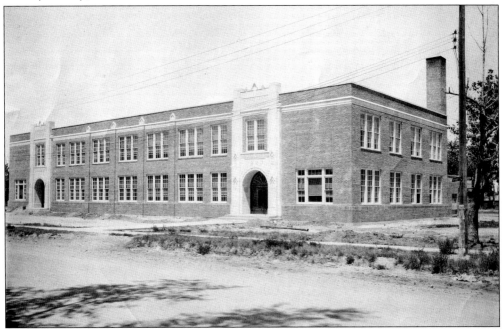

Wheatland High School was constructed in the 1920s and destroyed by fire in 1972, after which a new high school was built. This photograph shows the Wheatland Junior High School, which was built in 1927 with additions in the 1970s. This building currently serves as a Community Education Center. (Courtesy of the Platte County Library.)

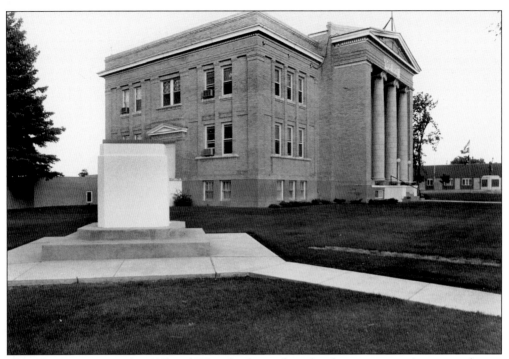

Platte County was created in 1911, and Wheatland was selected as the county seat. A new courthouse, shown in this photograph, was completed in 1917. A Carnegie library was constructed in the block north of the courthouse, also in 1917. It was the last library built in Wyoming through a grant from the Carnegie foundation. The Platte County Courthouse was placed on the National Register of Historic Places in 2009. (Courtesy of the Platte County Library.)

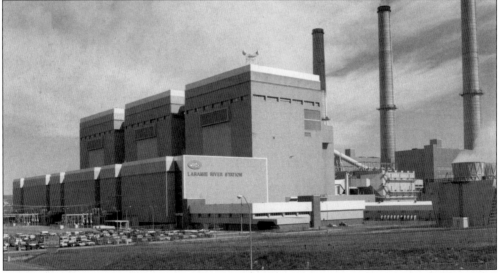

In 1980, the Missouri Basin Power Project's Laramie River Station opened northeast of Wheatland. The plant provides power to approximately two million residents in eight states and is a major employer in Platte County. During the construction phase of the project, in the 1970s, the population of Wheatland more than doubled from its base of around 2,300. (Courtesy of the Wyoming State Archives, Department of State Parks and Cultural Resources.)

Three

THE NORTH COUNTY

This log cabin was a schoolhouse for the Horseshoe Stage Station, built in 1861 south of the present town of Glendo. However, the Mormons had erected an immigrant trading post and claimed a block of land at the same location on Horseshoe Creek in the 1850s. The site served as one of seven mail stations joining Fort Laramie and Salt Lake City along the Mormon Trail. Historians say the Mormons burned the complex in 1857 as they fled before the arrival of a detachment of the U.S. Army. (Courtesy of the Platte County Library.)

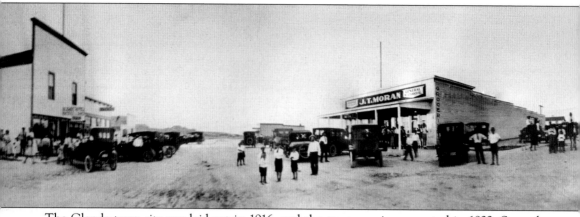

The Glendo town site was laid out in 1916, and the town was incorporated in 1922. Several businesses are shown in this panoramic 1920s photograph of the town of Glendo. (Courtesy of

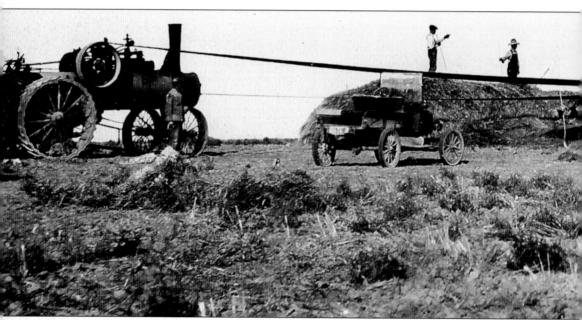

Farmers and ranchers settled in the Glendo area long before the town existed. The settlers lived along the North Platte River and along Elkhorn, Horseshoe, and Cottonwood Creeks. Meadowdale, Cassa, Horseshoe, and Cottonwood were thriving communities for many years. There was a

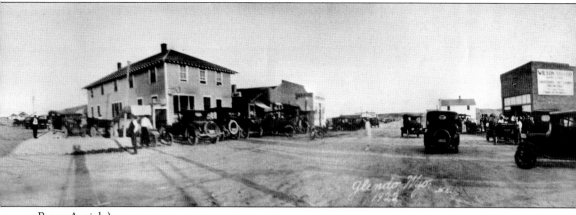

Betty Amick.)

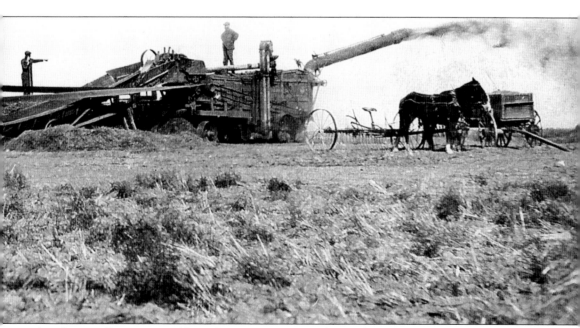

hotel, post office, store, and Pony Express station at Badger and a rail station at Wendover, both on Cottonwood Creek southeast of Glendo. This photograph shows settlers on Horseshoe Creek threshing grain using both horse and machine power. (Courtesy of Janette Chambers.)

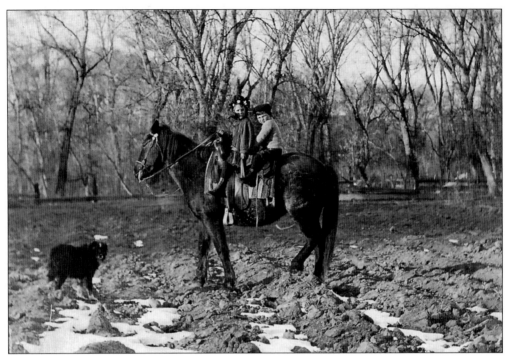

Stella Woody and Elmer Conlogue rode on horseback to the log schoolhouse on the Conlogue Ranch in the Horseshoe Creek community in 1914. Stella's father, James Woody, died in the flu epidemic of 1918, and her mother, Retta, despite being confined to a wheelchair, operated the ranch and taught school. Stella graduated from the University of Wyoming in 1930 and also became a teacher. She married Verne Martindale, and they ranched on Horseshoe Creek, where their daughter, Janette, and her husband, Pat Chambers, still reside. (Courtesy of Janette Chambers.)

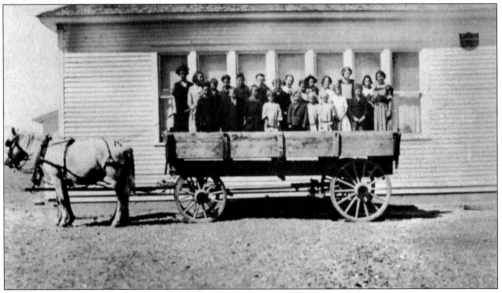

This photograph shows a wagonload of children in front of Glendo's first school about 1918. The horse-drawn wagon was an early version of a school bus. Virginia Collins was the first teacher at this school. (Courtesy of the Platte County Library.)

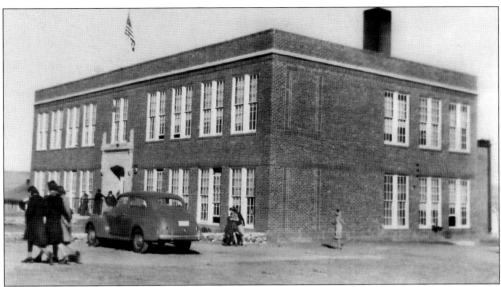

A new brick schoolhouse was constructed in Glendo in 1928. The school is shown in this photograph in 1940. (Courtesy of Betty Amick.)

William Hughes built the school bus parked on the left in front of the Glendo School in the 1930s. William and Mary Hughes lived in both Glendo and on a rural homestead. William drove his homemade school bus on the Horseshoe route for many years. He also served as a barber in Glendo and played violin, guitar, and banjo for the Saturday night dances held in various homes and barns in the Glendo area. (Courtesy of Betty Amick.)

The building on the left in this photograph was the Mountain View Hotel, built in 1917 by Ben Collins and his mother, Elizabeth Collins. Shown on the right is Ben Collins's garage. Dances were often held at the garage, as well as basketball games, before the brick school was built in 1928. (Courtesy of Betty Amick.)

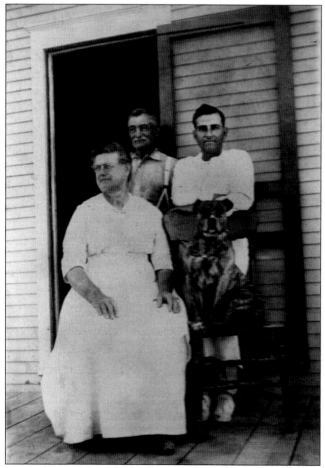

Elizabeth Collins (seated) was the proprietor of the Mountain View Hotel. The names of her two employees are unknown, but the dog's name was Jack. Elizabeth Collins was well respected in Glendo because she took a strong interest in the community. The hotel served as a gathering place for the community; church was sometimes held there, as was at least one funeral. (Courtesy of Betty Amick.)

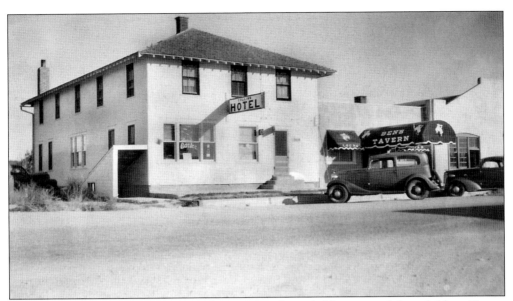

After Elizabeth Collins's death in 1938, her son, Ben; his wife, Virginia; and their children, Norma and Betty, moved into the Mountain View Hotel and changed the name to the Collins Hotel. Ben built an adjoining unit that became Ben's Tavern. (Courtesy of Betty Amick.)

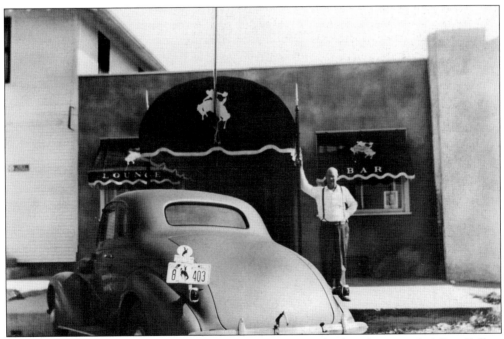

Ben's Tavern had a distinctive awning sporting the Wyoming bucking horse symbol. Ben Collins stands outside the tavern entrance in this 1942 photograph. In 1947, Ben built a tourist motel named the Bellwood Court that was managed by Ben's daughter, Betty, and her husband, Roy Amick. Ben also built a grocery and general store from baled straw and stucco in 1948. Betty Amick wrote that experts shook their heads and said the building would not last 20 years, but it still stands in Glendo. (Courtesy of Betty Amick.)

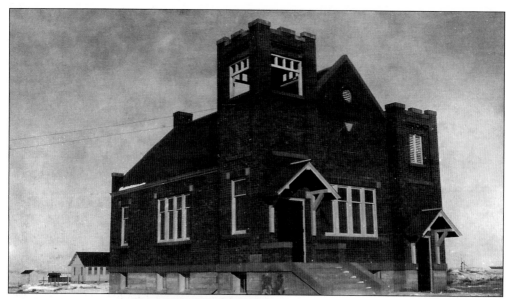

The first church in Glendo was the First Congregational Church, built in 1920 of locally kilned bricks from the Sorenson brickyard. The church became St. John the Baptist Episcopal Church in 1940. (Courtesy of Betty Amick.)

J. R. Wilson was a Glendo merchant, artist, homesteader, and amateur paleontologist. Wilson and his brothers, Gordon and Bayard, ran the Wilson Cash Store in Glendo from 1916 until 1951. J. R. Wilson accumulated an extensive collection of fossils, artifacts, and minerals that he kept in his private museum in Glendo. He was awarded a lifetime membership in the American Museum of Natural History in 1936. He was also known for his more than 400 oil paintings mostly of landscapes. Wilson died in 1956 at the age of 91, and his artifact collection is now displayed in the Glendo Historical Museum in the town hall. (Courtesy of Betty Amick.)

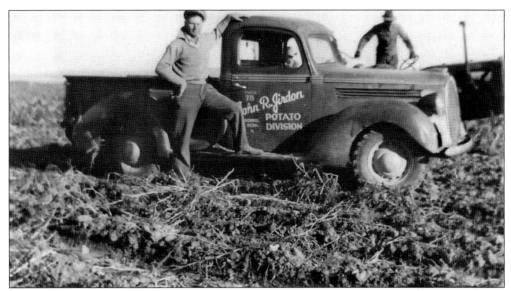

In 1938, the Jirdon Currier Potato Company of Morrill, Nebraska, leased land in the Glendo area to grow potatoes and built a large storage cellar. Many farmers participated, but the project was later halted due to the lack of labor resources, and the potato cellar became a bomb shelter. An article in *Time* magazine stated, "Tiny (population 296) Glendo, Wyoming. When the cold war started to heat up, the townsfolk pooled their resources, bought a vast potato cellar on the town's outskirts, and equipped it with water and sanitary facilities for 1,000 people." Glendo's mayor, Roy Amick, commented that the entire population of the town along with their automobiles could be moved into the cellar within 20 minutes. (Courtesy of Betty Amick.)

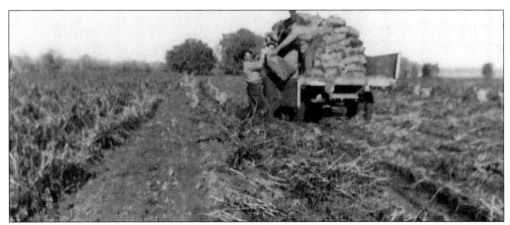

This photograph shows unidentified people loading sacks of potatoes into a truck in fields near Glendo. Before the advent of mechanical potato pickers, it was difficult to obtain seasonal help for the harvest. During World War II, there were prisoner of war camps in Douglas and Wheatland. German and Italian prisoners were brought to Glendo to harvest potatoes. The prisoners also worked on other farms in the Glendo and Wheatland area. (Courtesy of Betty Amick.)

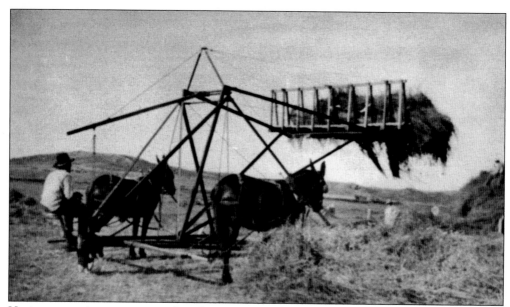

Haying was an important part of ranching on Horseshoe Creek near Glendo. It was necessary to harvest hay to feed the livestock during the long winter months. A valued part of the operation was a good team of draft horses. John Hughes is moving a load of hay with the use of a stacker in 1935. (Courtesy of Janette Chambers.)

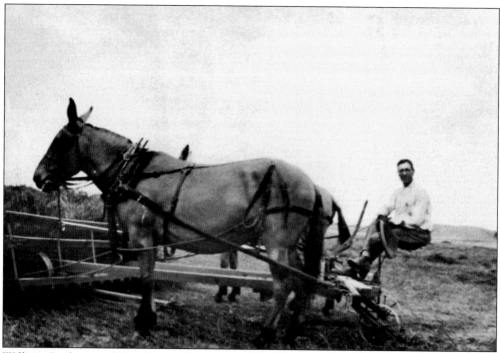

William Conlogue is driving his matched team of buckskin mules while pushing hay with a sweep. Conlogue and his wife, Elizabeth, operated a ranch on Horseshoe Creek for more than 40 years until William's death in 1947. John Hughes then served as manager of the Conlogue Ranch until 1965. (Courtesy of Janette Chambers.)

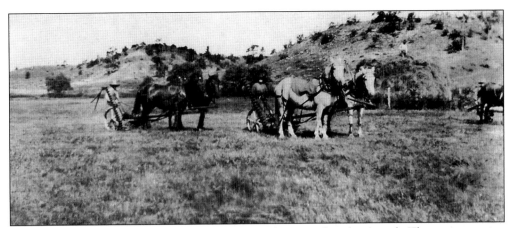

Unidentified drivers, with two teams of horses, are shown in this photograph. They are preparing to cut hay with mowing machines on the Conlogue Ranch. (Courtesy of Janette Chambers.)

In later years, many ranchers fashioned haying equipment from other pieces of machinery. This photograph shows a homemade hay sweep made from an old pickup. The haying crew includes, from left to right, Elizabeth Conlogue, Bob Phillips, William Conlogue, and Tillie Phillips. Families and neighbors often helped each other with ranch work such as haying. (Courtesy of Janette Chambers.)

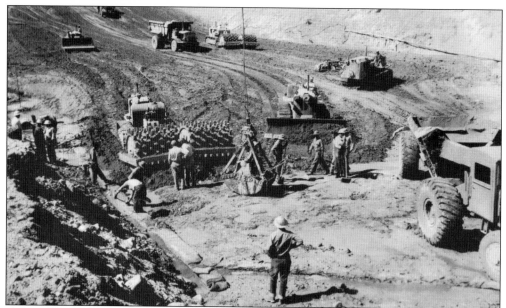

Construction was begun on Glendo Dam in 1954 and completed in 1957, and a power plant was completed in 1958. Glendo Dam is a multipurpose development providing supplemental irrigation water to 37,251 acres in Nebraska and Wyoming. The power plant provides electrical power to Colorado, Nebraska, and Wyoming. This photograph shows cleanup work in the downstream portion of a cut-off trench for the dam. (Courtesy of the U.S. Bureau of Reclamation, Wyoming Area Office; photograph by J. O. Monserud.)

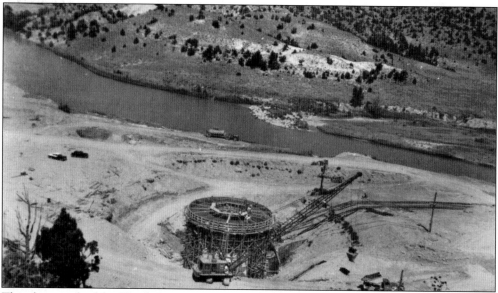

This photograph of the Glendo Dam project shows the placing of concrete on the intake structure of the dam. In addition to providing power generation and irrigation water, the Glendo Dam provides flood control, sediment retention, and water storage. The dam also provides recreation, fish and wildlife enhancement, and pollution control to improve the quality of both the municipal and industrial water supply along the North Platte River. (Courtesy of the U.S. Bureau of Reclamation, Wyoming Area Office; photograph by K. R. Underwood.)

This is the front of the program for the dedication ceremony of the Glendo Dam on June 9, 1959. Glendo mayor Roy Amick served as chairman of the dedication ceremony. Amick received a letter from Pres. Dwight D. Eisenhower reading in part, "The completion of Glendo Dam and Reservoir is a major step in the control and development of the water resources of the North Platte River. . . . Please give my congratulations to those have taken part in the enterprise, and my best wishes to all who will enjoy its many benefits." (Courtesy of Betty Amick.)

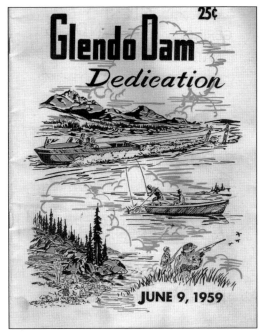

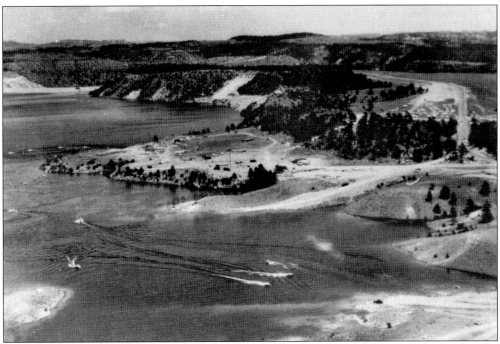

This photograph shows how the Glendo Reservoir looked on dedication day in 1959. The lake created 12,500 acres of water for skiing, boating, swimming, and fishing. The project was not considered beneficial by everyone because several historic ranches, landmarks along the Oregon, Mormon, and Overland Trails, and areas of archeological importance were flooded. Glendo State Park encompasses a large portion of the land around Glendo Dam, offering camping sites, boat ramps, hiking trails, picnic areas, playgrounds, and other amenities. (Courtesy of the U.S. Bureau of Reclamation, Wyoming Area Office.)

This photograph shows the many temporary mobile homes occupied by workers and their families during the construction of Glendo Dam. (Courtesy of Sandra Sommers.)

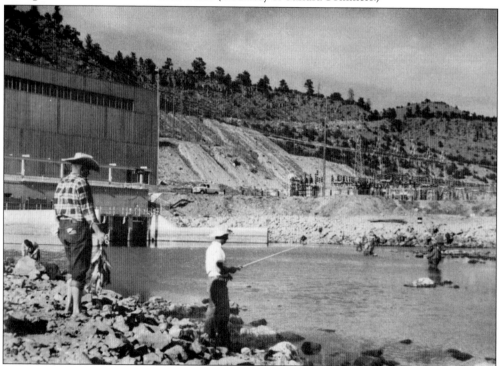

Fishing became a popular sport among locals and visitors following the construction of Glendo Dam. Fishermen are shown below the Glendo Power Plant after the 1960 irrigation season flows were terminated. A typical creel limit of 12 fish was often taken from this stilling basin about two weeks after high water flows ended in September. (Courtesy of the U.S. Bureau of Reclamation, Wyoming Area Office; photograph by L. Wenzel.)

Four

THE EAST COUNTY

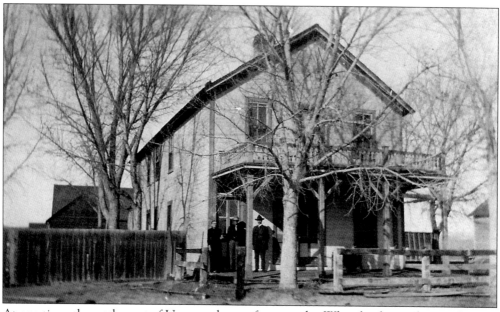

At one time, the settlement of Uva, northeast of present-day Wheatland, was the social center of the area along the Laramie River. Billy Bacon established a roadhouse there in 1876 that was later relocated. Hubert Teschemacher and Fred de Billier built the Uva Hotel, shown in this photograph, in 1910. Uva was the railroad shipping point to Omaha and Chicago for livestock from many area ranches. But when the Wyoming Development Company chose Wheatland for its headquarters, Uva began to decline, and the post office there closed in 1940. (Courtesy of the Platte County Library.)

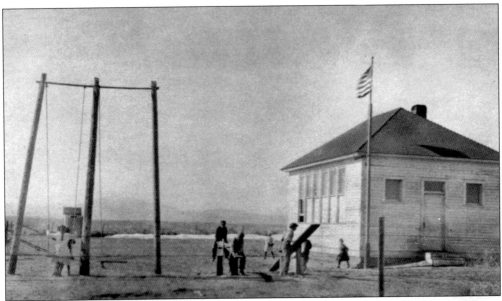

Farmers and ranchers had settled in the area of Dwyer, northeast of Wheatland, but the town began to boom with the arrival of the railroad. A post office was established in 1910, followed by a bank, blacksmith shop, mercantile stores, restaurant, lumberyard, printing shop, newspaper, churches, and a school. This photograph of the Dwyer School shows the new flag, flagpole, and playground equipment. This was a typical standardized school of the 1920s and 1930s. (Courtesy of the Platte County Library.)

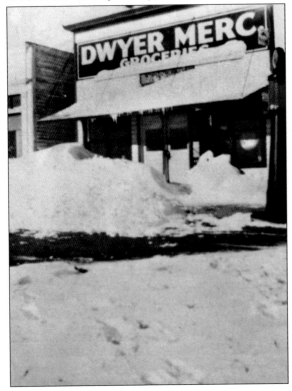

The Dwyer Mercantile store was open for business in 1929 despite the large snowdrifts. Trains brought passengers, freight, and the mail to Dwyer. By 1931, the depot was closed, and in the 1960s, train service was discontinued. Many of the Dwyer buildings were sold and moved to other locations. All that remains are a few private homes on the windswept prairie along Wyoming State Highway 26. (Courtesy of the Platte County Library.)

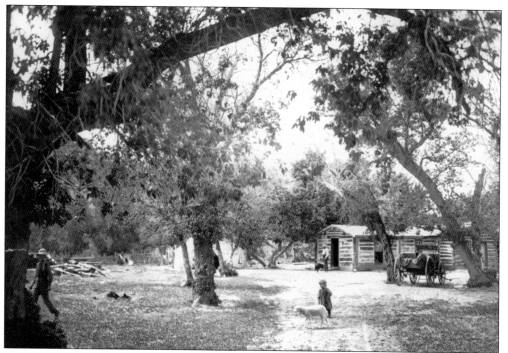

Many of the first settlers claimed land along the North Platte and Laramie Rivers. Early ranches and homesteader's claims existed at Grayrocks and Bettelyoun Flats. A settlement named Fairbanks sprang up just north of Guernsey. There was a short-lived copper mining boom in the area, including a copper smelter, around 1880. This photograph shows an early homestead in Fairbanks. (Courtesy of the J. E. Stimson Collection, Wyoming State Archives, Department of State Parks and Cultural Resources.)

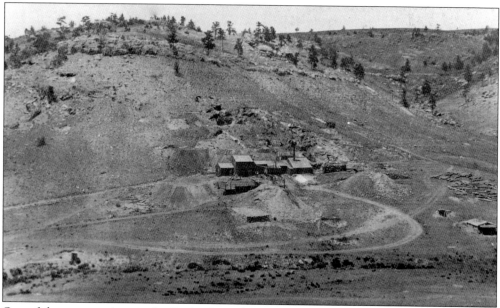

One of the copper mines in the Fairbanks and Hartville area of Platte County is shown in this photograph around 1880. (Courtesy of the Platte County Library.)

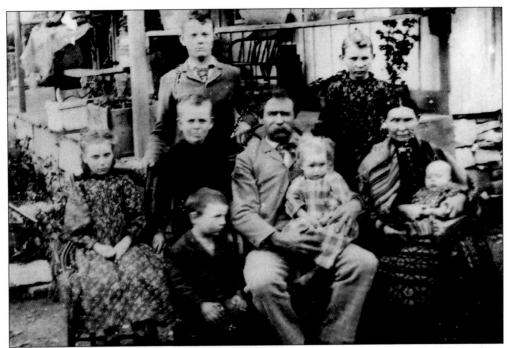

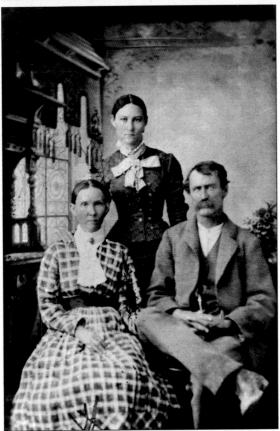

Asa Covington homesteaded 15 miles north of Hartville in 1897. Covington came to Wyoming from Texas with 9 of his 13 children and established a large cattle ranching operation. Asa and his wife, Melinda, are shown with several of their unidentified children. By 1917, the ranching enterprise included many of the Covington family members and employed other workers. Covington was said to have ruled his empire for 20 years before new homesteaders began to threaten his open range by erecting fences. (Courtesy of Russell Covington.)

Melinda Covington (seated left) and her husband, Asa Covington (seated right), are shown with one of their daughters, Mary Catherine, in 1887, before the family moved to Wyoming. When the family arrived in Wyoming, they lived in a tent until a three-room house with dirt floors was erected. Eventually the house had a huge stone fireplace, wooden floors, and several more rooms containing comfortable furniture. (Courtesy of Russell Covington.)

In 1917, Raymond Eaton purchased the relinquishment of the Green Nicks homestead in the middle of the Covington Ranch, sparking a Platte County range war. Raymond's daughter, Phoebe Eaton DeHart, recalled details of the incident in her writings. According to DeHart, Covington and his employees tore down fences, drove cattle over the fields, and drove horses and milk cows from the Eatons' and other homesteaders' properties. Finally one homesteader, Doug Roberts, confronted Covington's enforcer, W. E. Jackson, resulting in a fight in which Roberts shot and killed Jackson. Roberts immediately gave himself up to the sheriff in Wheatland, remained in jail for 11 months, and was acquitted at his trial in 1922. The jury found that Roberts had acted in self-defense. DeHart wrote that Asa Covington eventually lost his fortune, and by the 1930s, he lived alone and in poverty on his ranch. Covington had to drive through the Eaton property to go to town, and one day he was invited into the Eaton house for a meal, which he accepted. Covington reportedly told Eaton that if he had his life to live over he would live it differently, and Raymond Eaton considered that statement as an apology. (Courtesy of Phoebe Eaton DeHart.)

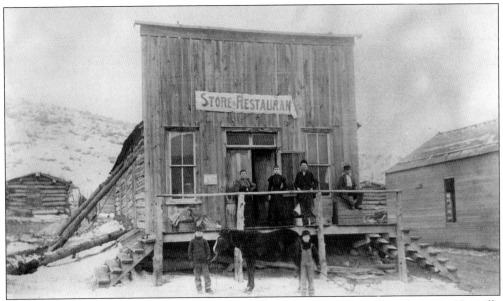

Prospectors seeking gold, silver, copper, and iron settled the town of Hartville in the 1870s. Hartville became a thriving mining community as well as the trading and entertainment center for the area's cattle ranches, homesteaders, and military personnel from nearby Fort Laramie. Gambling, drinking, and women were the major attractions in the early days of the roaring frontier town. This store and restaurant was one of the many businesses found in Hartville. (Courtesy of the Wyoming State Archives, Department of State Parks and Cultural Resources.)

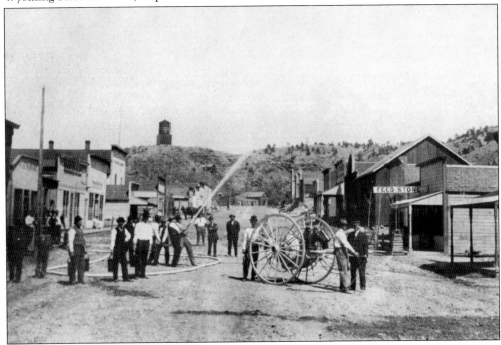

A few years after Hartville was founded, the residents formed a volunteer fire department. Members of the fire department are shown testing a water hose in the early 1900s. (Courtesy of Darrell and Marian Offe.)

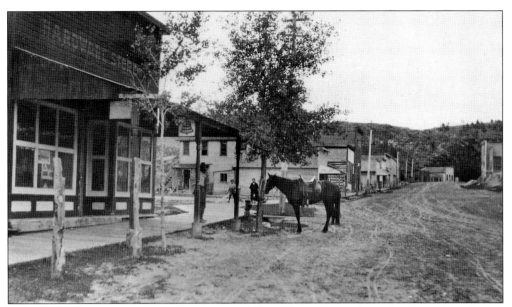

By 1900, the railroad line was extended to Hartville, and mining accelerated in the nearby Sunrise iron ore mine. Businesses had expanded along Hartville's main street, and more people began to move into the town. The *Hartville Iron Gazette* reported the opening of five general grocery stores, three new saloons, two drugstores, four barns and livery stables, two restaurants, and a laundry. (Courtesy of Darrell and Marian Offe.)

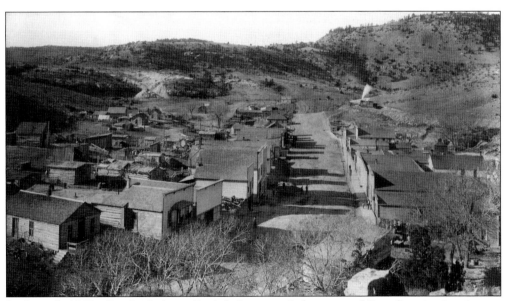

In the early 1900s, Greeks, Italians, English, Japanese, Lebanese, and Scandinavian immigrants came to live in Hartville and Sunrise. Most came to work in the Sunrise mines, although many lived in Hartville and established homes and businesses there. This photograph is of Hartville's main street in 1902. (Courtesy of Darrell and Marian Offe.)

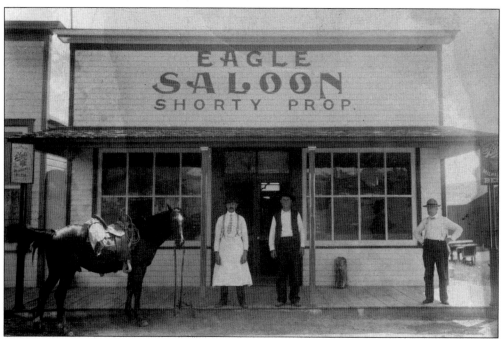

This is one of the dozens of saloons that operated in Hartville during its early boom years. (Courtesy of the Platte County Library.)

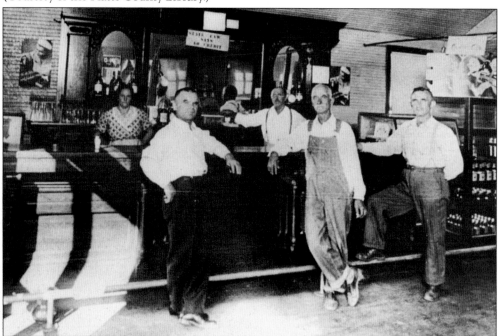

The Miner's Bar in Hartville claims to be the oldest bar in Wyoming. The back bar, shown in this photograph, was built in Germany in 1864 and brought to Hartville in the 1870s. Owners of the Miner's Bar in the 1920s were Maria Testolin and her husband, Guildo, shown behind the bar. Domenic Balzan is shown in front of the bar on the left with two unidentified patrons. (Courtesy of Fred and Alice Dapra.)

Chris and Daisy Fletcher were two of Hartville's many notorious citizens. Chris owned several businesses including a saloon, and together they operated the Hartville Opera House. Daisy was known as one of several bordello madams operating in Hartville, and Daisy's girls were deemed to be among the most favored. (Courtesy of the Platte County Library.)

This woman, whose name is unknown, was one of the dancers in the Fletcher Opera House in Hartville. Her companion is Tony Konopisos. (Courtesy of Fred and Alice Dapra.)

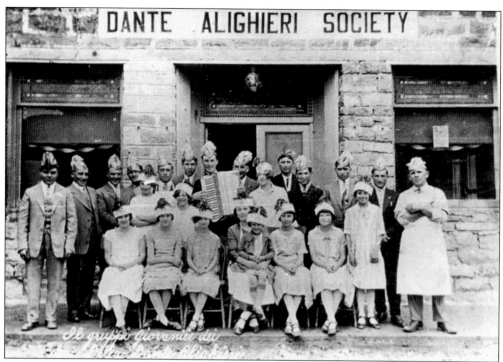

The Dante Alighieri Society in Hartville was a multifunctional society that provided sick and death insurance benefits for its Italian members as well as social events. The Greeks had a similar organization named the Hellenic Society. These unidentified members of the Dante Alighieri Society are shown in front of their meeting hall in 1920. The Episcopal Church of Hartville currently owns the building. (Courtesy of Fred and Alice Dapra.)

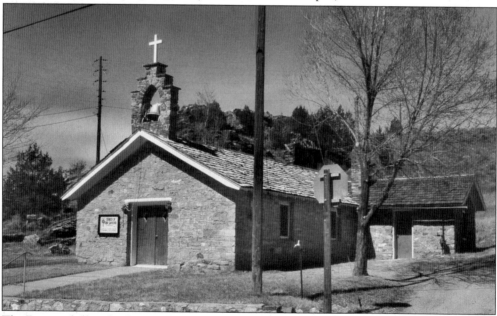

The Episcopal Church of Hartville was an early church and still holds services in the community. (Courtesy of Darrell and Marian Offe.)

The Testolin family became one of Hartville's most enterprising families. Attilio Testolin operated a store known as A. Testolin and Sons for five years in the 1920s. The store was renamed the Hartville Mercantile Company in 1931 and was operated by Attilio's son Dante, who dubbed it "Wyoming's biggest little store." Shown in front of the store in 1929 are, from left to right, Guildo Testolin, Frank Brazzale Jr., Dante Testolin, Red Testolin, Nita Seracati, Cattina Testolin, Antonio Testolin, and Wilbur Francescato. (Courtesy of Darrell and Marian Offe.)

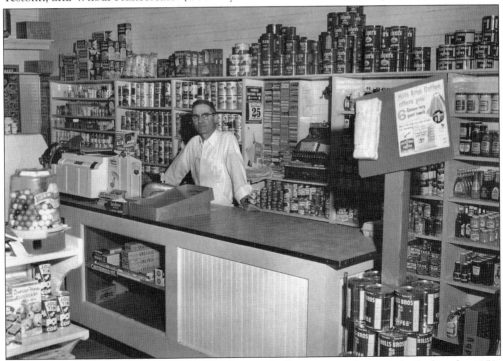

Dante Testolin is shown in the Hartville Mercantile Company as the store looked in the 1950s and 1960s. The store was closed in 1966, and today a portion of the building is the home of Dante's daughter, Marian, and her husband, Darrel Offe. The American Cowboy Coffee Company occupies the front part of the building. (Courtesy of Darrell and Marian Offe.)

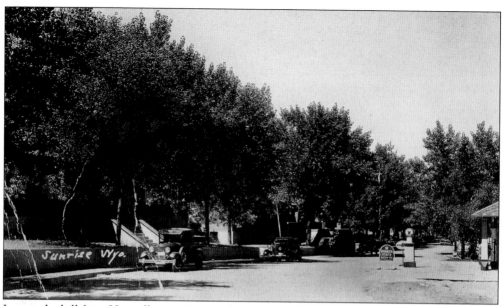

Just up the hill from Hartville was Sunrise, founded as a mining town. Its tree-shaded streets are shown in the early 1900s. (Courtesy of Darrell and Marian Offe.)

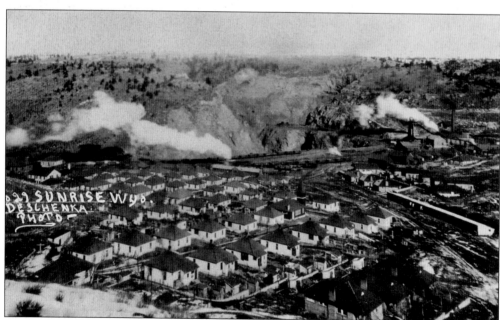

Sunrise was the town the company built. The Colorado Fuel and Iron Company established the community and the iron ore mining operation there in 1899. The company homes in this photograph housed many of the mine's 700 workers at the peak of operation. After the mine closed in 1980, most of the houses were torn down. (Courtesy of Darrell and Marian Offe.)

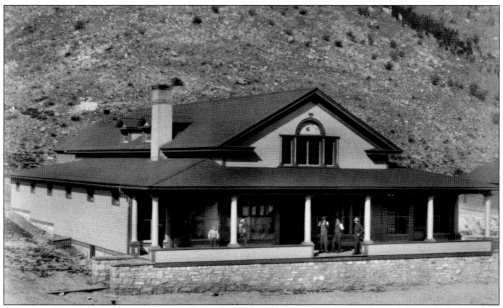

The Colorado Fuel and Iron Corporation had its own store in Sunrise where the miners and families could obtain nearly everything they needed. (Courtesy of the J. E. Stimson Collection, Wyoming State Archives, Department of State Parks and Cultural Resources.)

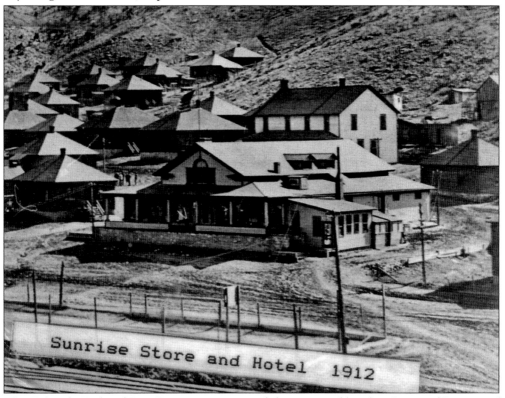

Sunrise Store and Hotel 1912

The Colorado Fuel and Iron Corporation operated this store and hotel in Sunrise. (Courtesy of Darrell and Marian Offe.)

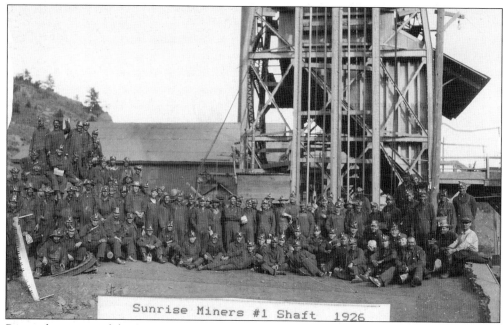

Sunrise Miners #1 Shaft 1926

Pictured is a view of the Sunrise miners in front of Shaft No. One in 1926. The ore was mined in Sunrise and shipped by railroad to Pueblo, Colorado, for smelting. (Courtesy of Darrell and Marian Offe.)

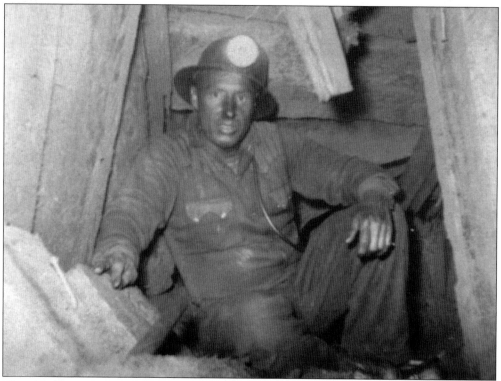

Chet Maddox was one of the miners who worked at the Sunrise Mine, shown here in 1958. (Courtesy of Elvira Call.)

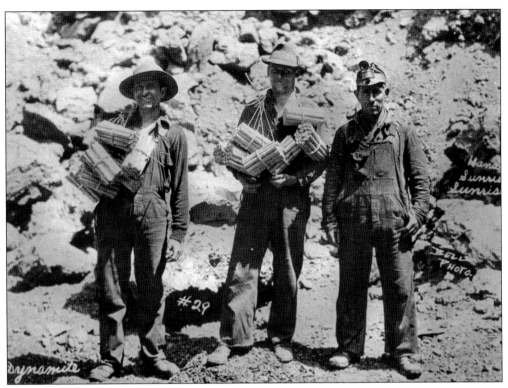

These Sunrise miners holding sticks of dynamite are, from left to right, Joe Francescato, Joe Boria, and Joe Caligiore Sr. (Courtesy of Darrell and Marian Offe.)

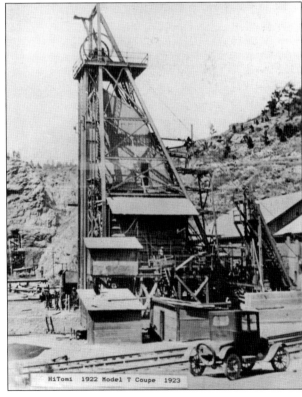

This photograph shows one of the shafts of the Sunrise Iron Ore Mine in 1923. Parked in front of the mine is a 1922 Model T Ford coupe. (Courtesy of Darrell and Marian Offe.)

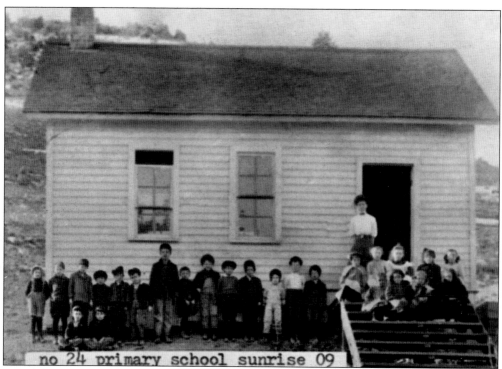

no 24 primary school sunrise 09

Several pupils and their teacher are shown in this 1909 photograph of the Sunrise School. (Courtesy of Darrell and Marian Offe.)

By 1915, the Colorado Fuel and Iron Company had built a much larger brick junior and senior high school in Sunrise. (Courtesy of Darrell and Marian Offe.)

The first YMCA building in Wyoming was constructed in Sunrise in 1917 at a cost of $40,000. It had a marble-topped soda fountain, a fully equipped kitchen, an auditorium, a gymnasium, a bowling alley, a card room, a billiard and poolroom, a barbershop, a ladies lounge with a sewing machine, and a reading room. Classes were held there as well as amateur theatricals, boxing and wrestling matches, movies, dances, and various club and youth activities. The YMCA building is one of the few remaining structures on the old Sunrise site, though it is on private property and cannot be visited without permission. (Courtesy of Darrell and Marian Offe.)

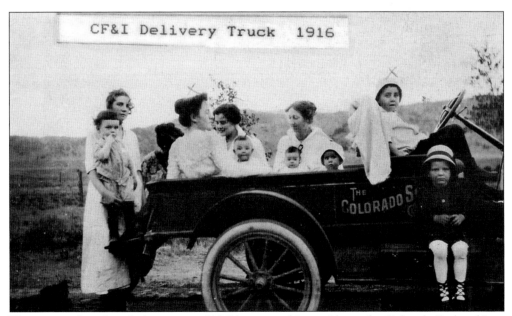

This group of unidentified women and children are taking a ride on the Colorado Fuel and Iron Company truck in 1916. (Courtesy of Darrell and Marian Offe.)

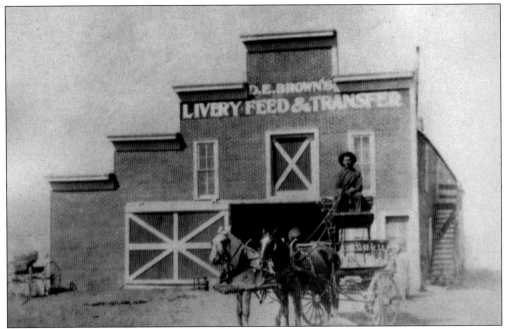

One of the earliest buildings in Guernsey was this livery, feed, and transportation business. Guernsey, a town along the banks of the North Platte River, was named for Charles A. Guernsey, a prominent rancher, legislator, and entrepreneur who settled in the area in the late 1800s. (Courtesy of Fred and Alice Dapra.)

As the town of Guernsey grew, many other businesses were opened. This view shows the Guernsey Mercantile building after the town became established. The Burlington Northern Railroad arrived in 1900 and was a factor that aided in the development of the town. (Courtesy of the Platte County Library.)

This view of the Guernsey Hotel in the early 1900s shows a group of people gathered for an unknown event. (Courtesy of Fred and Alice Dapra.)

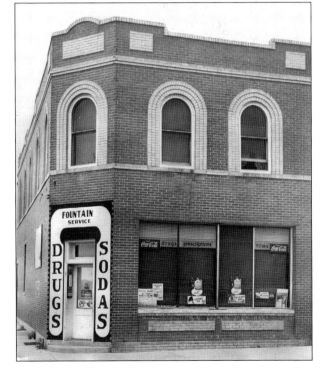

The Guernsey drugstore and soda fountain occupied this building in Guernsey. (Courtesy of the Platte County Library.)

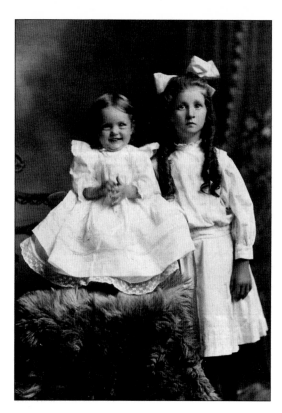

Margaret Sutherland (left), age one, and her stepsister, Bernice Sutherland, age five, were born in Glendo but lived in Guernsey as young adults. This photograph was taken about 1910. (Courtesy of Betty Amick.)

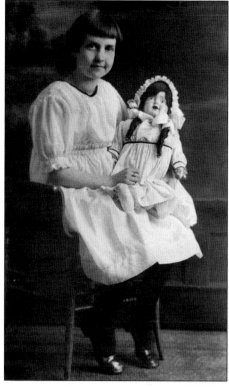

Pretty little Margaret Sutherland, age eight, is holding her doll in this 1917 photograph. She lived in Glendo and Wheatland as a child but moved to Guernsey in the 1920s. She married Cecil James and operated a beauty shop in Guernsey for more than 30 years. (Courtesy of Betty Amick.)

The James family became residents of
Guernsey around 1900. From left to
right are (first row) Thomas, Cecil,
Mary Ellen, and Elizabeth; (second
row) Gladys and Winifred. The little
boy, Cecil, grew up to marry Margaret
Sutherland. He worked in the Sunrise
Mine. (Courtesy of Betty Amick.)

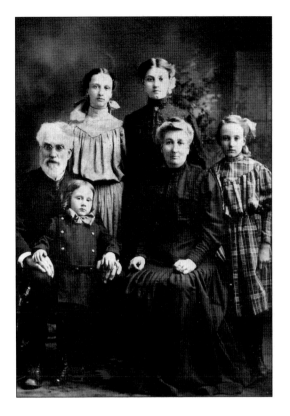

This photograph of Cecil James and Margaret
Sutherland was taken for their wedding on
May 25, 1930. (Courtesy of Betty Amick.)

This is an interior view of the first barbershop in Guernsey around 1920. Bill Cook is in the center of the photograph, and his son, Kirk, stands in the corner. (Courtesy of the J. E. Stimson collection, Wyoming State Archives, Department of State Parks and Cultural Resources.)

Students gather outside of Guernsey High School in this early photograph. (Courtesy of Fred and Alice Dapra.)

The Guernsey Depot is shown here. The railroad was important to the development of Guernsey and currently operates as a division point for the Burlington Northern Railroad. (Courtesy of Fred and Alice Dapra.)

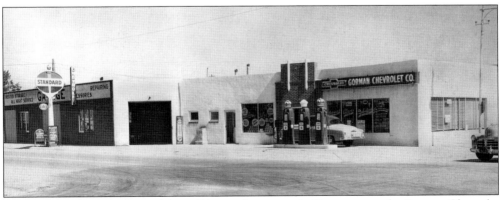

By the mid-20th century, one of the well-known businesses in Guernsey was the Gorman Chevrolet Company. (Courtesy of the Platte County Library.)

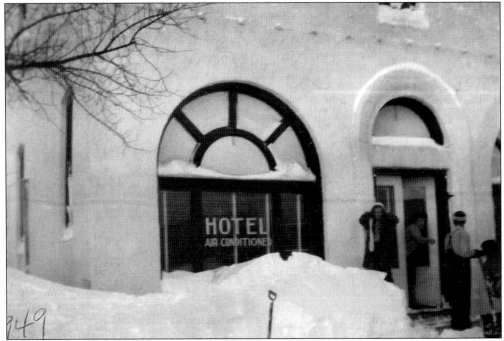

This photograph shows the deep snowdrifts that paralyzed towns in southeastern Wyoming following a blizzard that began on January 2, 1949. Snowfall in parts of southeastern Wyoming measured nearly 3 feet, and the wind blew drifts more than 30 feet high. This scene in front of the Guernsey Hotel was taken on the fourth day after the blizzard. (Courtesy of Elvira Call.)

Lawrence Larson walks down Main Street in Guernsey, which has filled with snow following the 1949 blizzard. Thousands of motorists and rail passengers were stranded all over southeastern Wyoming and western Nebraska for days, and it took weeks to clear all the roads and check on rural residents. (Courtesy of Elvira Call.)

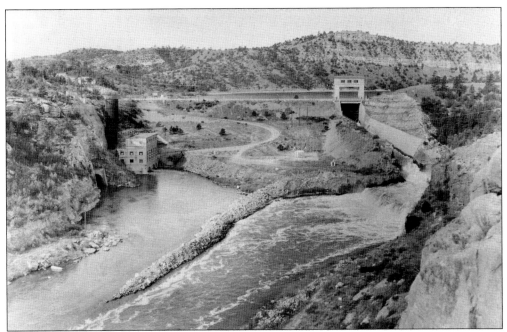

The Bureau of Reclamation built Guernsey Dam on the North Platte River from 1925 to 1927. The earthen dam has a height of 105 feet and a length of 560 feet and includes a power generation plant. Built primarily for irrigation purposes, the dam also serves as a popular swimming, boating, and fishing area. (Courtesy of Darrell and Marian Offe.)

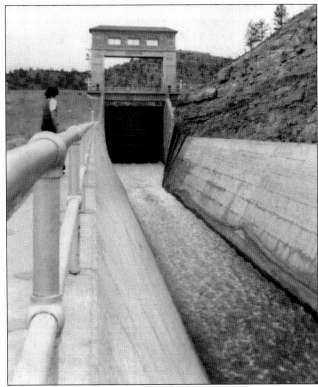

A woman is shown walking along the path beside the spillway of the Guernsey Dam in 1940. (Courtesy of Betty Amick.)

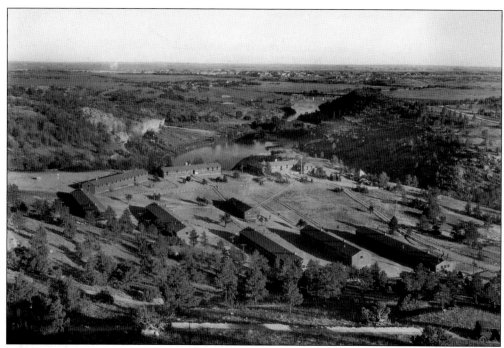

Guernsey State Park was created when the Civilian Conservation Corps (CCC) went to work in 1933. This is a view of the Guernsey CCC Camp. (Courtesy of the J. E. Stimson collection, Wyoming State Archives, Department of State Parks and Cultural Resources.)

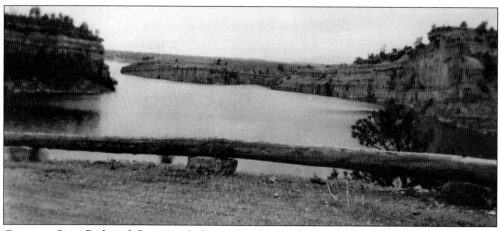

Guernsey State Park and Guernsey Lake are 2 miles northwest of the town of Guernsey. Water skiers, boaters, picnickers, campers, hikers, bikers, wildlife lovers, and bird-watchers enjoy the bounty of Guernsey State Park. There are seven campgrounds with 142 campsites within the park. (Courtesy of Betty Amick.)

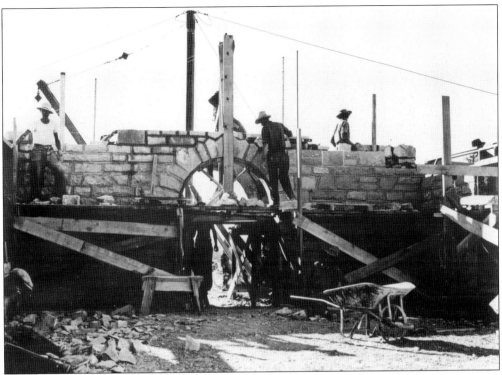

Guernsey State Park was the first cooperative venture between the Bureau of Reclamation, the National Park Service, and the Civilian Conservation Corps to develop a public recreation area. Guernsey was one of the first places where CCC workers were allowed to perform skilled labor. This photograph shows CCC workers completing the stone arch at the Guernsey Lake Museum in the 1930s. (Courtesy of the J. E. Stimson collection, Wyoming State Archives, Department of State Parks and Cultural Resources.)

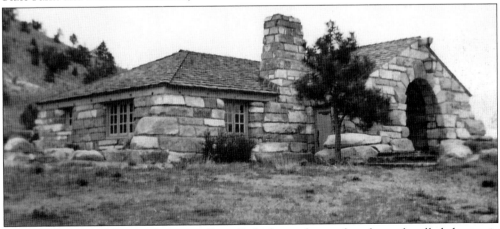

The completed museum at Guernsey State Park shows the results of a craft called the rustic architectural movement, developed by Conrad Wirth and Thomas Vint. The basis of rustic architecture was simplicity in design, use of native building materials, avoidance of overly perfect construction lines, and a general feeling of having been built by pioneer craftsmen. The historic portions of Guernsey State Park have been left unmodified since they were constructed in the 1930s. (Courtesy of Betty Amick.)

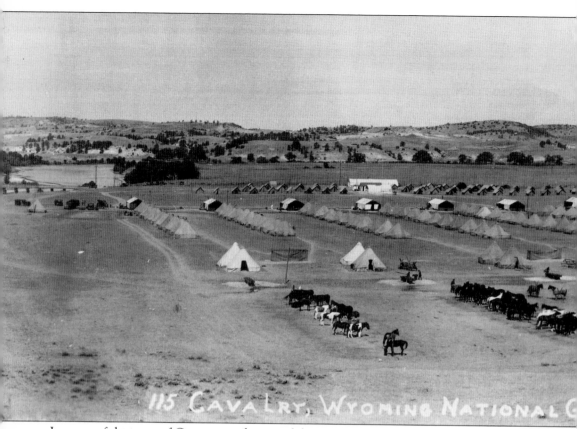

115 CAVALRY, WYOMING NATIONAL G

Just east of the town of Guernsey is the site of the Wyoming National Guard Training Camp. The National Guard's first encampment at Guernsey took place in June 1939, when 700 soldiers from Wyoming units, including the 115th Cavalry Regiment with their horses, took part in the maneuvers. The camp replaced the Wyoming Army National Guard's Pole Mountain Camp.

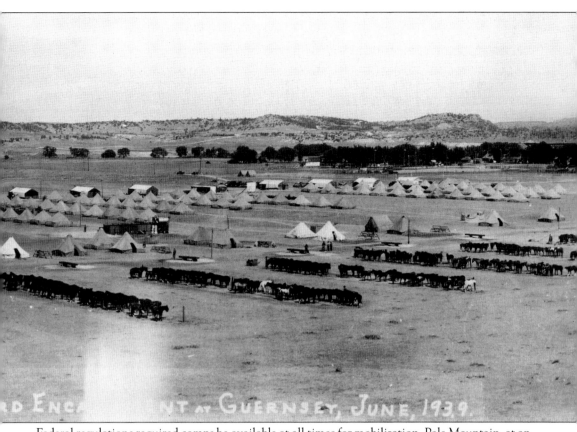

D Enc NT AT GUERNSEY, JUNE, 1939.

Federal regulations required camps be available at all times for mobilization. Pole Mountain, at an elevation of 8,600 feet in the Laramie Range, was closed by snow for a good part of the year; had an insufficient supply of water; and, even in the summer, the nights were too cold for camping. (Courtesy of the Wyoming National Guard Museum.)

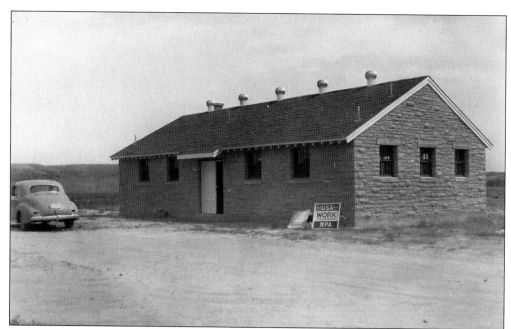

Camp Guernsey was formally established in 1939 as a state-owned training facility, and the Works Progress Administration (WPA) began the construction of permanent buildings. WPA workers constructed this building at the Wyoming National Guard Camp near Guernsey. (Courtesy of the Wyoming National Guard Museum.)

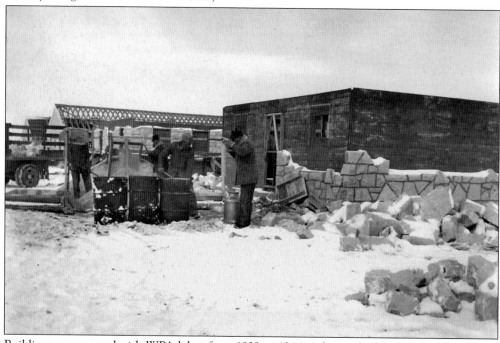

Buildings constructed with WPA labor from 1939 to 1944 make up the historical district of the Guernsey camp. During World War II, Camp Guernsey was an active army training center; National Guard training resumed in the early 1950s. (Courtesy of the Wyoming National Guard Museum.)

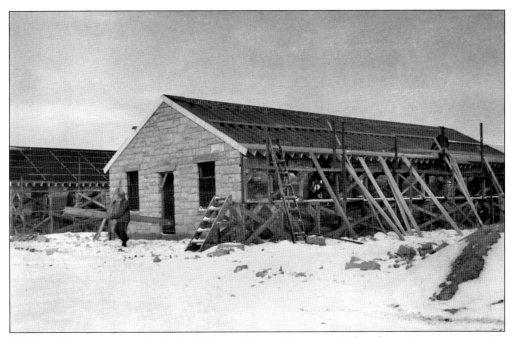

WPA workers constructed this building at Camp Guernsey. Today the main camp contains administrative buildings and maintenance, supply, and storage facilities in addition to troop barracks. An airstrip was built in 1987 and is shared with the town of Guernsey to accommodate military and civilian aircraft. (Courtesy of the Wyoming National Guard Museum.)

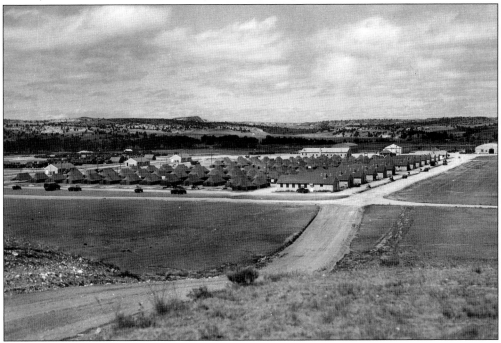

Today the Wyoming National Guard Camp has more than 60,000 acres and hosts military units, civilian law enforcement, and other agencies throughout the year. In 2008, the camp employed more than 200 personnel. (Courtesy of the Wyoming National Guard Museum.)

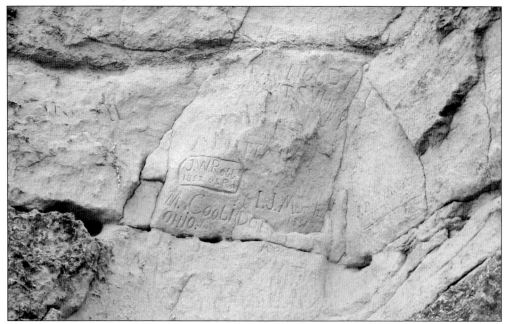

Register Cliff, 2 miles southeast of Guernsey, provided travelers with a place to leave their names and messages for those who followed. The 100-foot-high cliff of soft limestone was formed by thousands of years of water and wind erosion near the banks of the North Platte River. The landmark remains much as it was when early travelers camped there as they followed the trails from 1829 until around 1869. (Courtesy of Starley Talbott.)

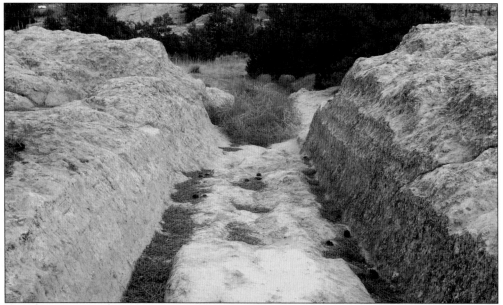

The wheels of many wagons left a lasting memory of the thousands of travelers who followed the Oregon Trail, resulting in a clearly defined and deeply grooved road. Not until 1869, when the Union Pacific Railroad was completed, did use of the trail begin to decline. Wagon ruts can be seen in many places in Wyoming, but some of the best examples are located a half-mile west of Guernsey at the Oregon Trail Ruts National Landmark. (Courtesy of Starley Talbott.)

Five

THE SOUTH COUNTY

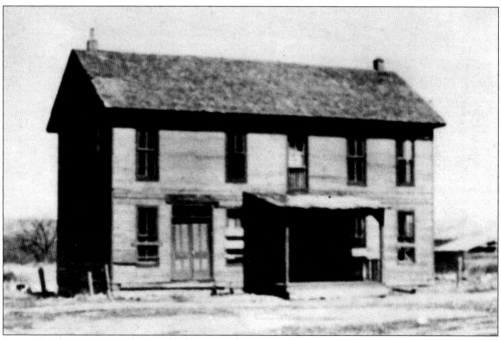

James Bordeaux, a Frenchman, built a wayside station south of the present town of Wheatland in 1867. John Hunton took over in 1870 and operated a stage and mail station between Forts Laramie, Fetterman, and D. A. Russell. In 1887, Hunton built the Bordeaux Hotel, shown in this photograph, at the terminus of the Cheyenne and Northern Railroad. Horse-drawn wagons then hauled the mail and supplies east to Fort Laramie. Various owners operated the Bordeaux Hotel, store, and post office until it was torn down in 1938. John Hunton also operated a ranch with his brothers Thomas and James; the latter was killed by Native Americans in 1875. John and his wife, Blanche, moved to Fort Laramie in 1888 when he was appointed as post trader, remaining in the area the rest of their lives. Thomas Hunton served as Bordeaux postmaster until 1896, when he and his wife, Mora, moved to Wheatland. (Courtesy of the Platte County Library.)

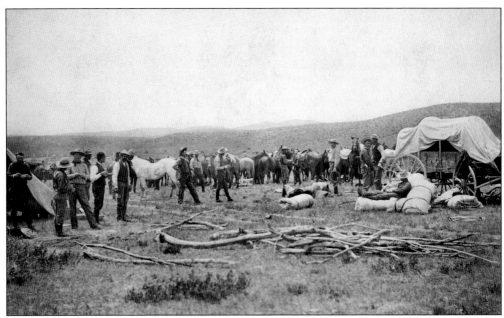

In the mid- to late 1800s, the land in Wyoming was open range for livestock ranches. Huge roundups were held each fall to gather the cattle from several ranches and sort them for shipment to market. This photograph shows the cowboys making camp during one of the roundups on Richeau Creek between Chugwater and Wheatland. (Courtesy of Fred and Mickey McGuire.)

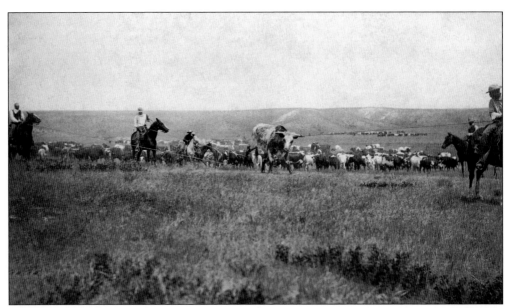

Cowboys are shown roping a steer during a roundup on Richeau Creek around 1880. This area would eventually become part of the southern portion of Platte County. (Courtesy of Fred and Mickey McGuire.)

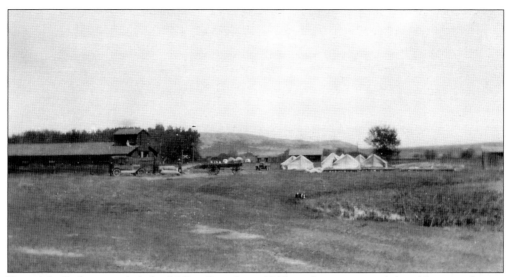

Dave MacFarlane settled the M Bar Ranch in 1866, making it one of the oldest ranches in Platte County. The ranch, on Chugwater Creek at Slater, was sold to the Swan Land and Cattle Company, who ran both cattle and sheep. The M Bar was the location of several large pens used to shear the Swan Company sheep. (Courtesy of the Chugwater Museum.)

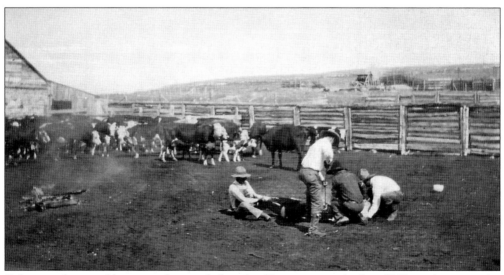

Other ranchers and homesteaders settled in the Slater area in the late 1800s and on into the 1900s. This photograph shows a branding at one of the ranches. Neighbors often got together to help each other out. (Courtesy of Ruth Chase Irvine.)

Workers driving teams of horses are harvesting hay from the meadows along Chugwater Creek for the M Bar Ranch around 1910. In the background is the well-known landmark Chimney Rock. (Courtesy of the Chugwater Museum.)

Brothers Wes and Ellis Slater settled near the railroad tracks north of Chimney Rock in 1910. Their building housed a grocery store, post office, and railroad depot. The original post office had been called Chimney Rock for the large rock formation south of the community. The town name was changed to Slater and grew to several houses, a grain elevator, three grocery stores, a bank, a blacksmith shop, a school, and a meeting hall. Slater community residents are shown at a Fourth of July picnic near Chimney Rock in the 1940s. (Courtesy of John and Betty Baker.)

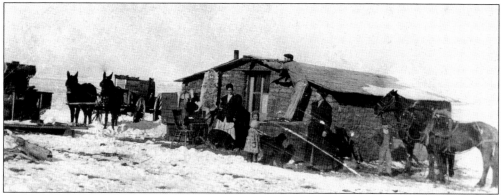

Several of the early homesteaders lived in sod houses until they could build a new home. In this 1911 photograph, the Goering family moved from Cora Slater's old sod house to their new home a mile west in the area known as the Slater Flats. The sod house later served as a school on the Slater Flats. In the early 1900s, there were several rural schools in each community, so no child had to walk or ride more than 3 miles to attend school. (Courtesy of the Platte County Library.)

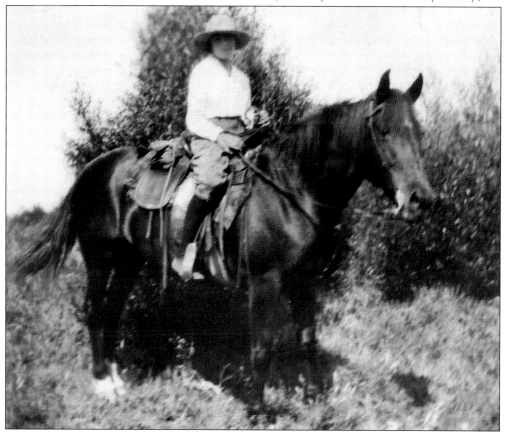

Ruth Chase was born on the homestead of her father, James, near Chugwater. Shortly after that, the family moved to a ranch on Richeau Creek near Slater. Ruth grew up on the family ranch, where she often rode her horse, Pet, to school and to visit a friend on a neighboring ranch. She married James Irvine in 1941 and moved to a ranch 3 miles north of where she had grown up. Ruth is a lifetime member of the Slater Women's Club. (Courtesy of Ruth Chase Irvine.)

Ralph and Zelma Baker farmed near Slater from 1938 to 1966. Their farm, along with many others, was nearly buried during the famous 1949 blizzard. They were among the fortunate farmers who sustained few losses during the blizzard. In the entire area of the storm that covered parts of Wyoming, Nebraska, and South Dakota, 17 people perished, along with 55,000 head of cattle and more than 100,000 sheep. (Courtesy of John and Betty Baker.)

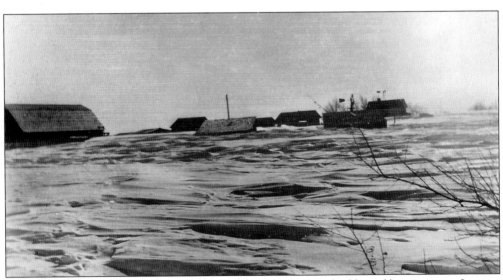

Wind whipped the mounds of snow for weeks following the four-day blizzard beginning on January 2, 1949. This photograph shows the windswept prairie on the Ralph Baker farm near Slater following the storm. The Bakers' son, John, and his wife, Betty, took over the operation of the farm in 1966. (Courtesy of John and Betty Baker.)

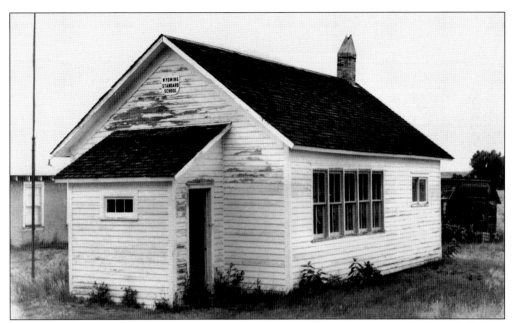

A new school was built in the town of Slater in 1917. The Slater Community Hall was built next to the school in the late 1930s as a gymnasium for the school and as a community building. Slater Hall has been used over the years for dances, club meetings, the Slater Sunday school and vacation bible school, and the Slater Women's Club. It continues to be used today and is maintained by a community organization. (Courtesy of the Platte County Library.)

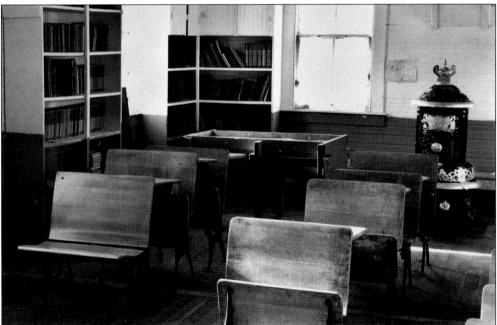

This photograph shows the interior of the Slater Schoolhouse as it would have looked when students attended in the early to mid-1900s. The Slater community has restored this school to its original condition and furnished it with desks, stoves, books, and blackboards of the original era. (Courtesy of the Platte County Library.)

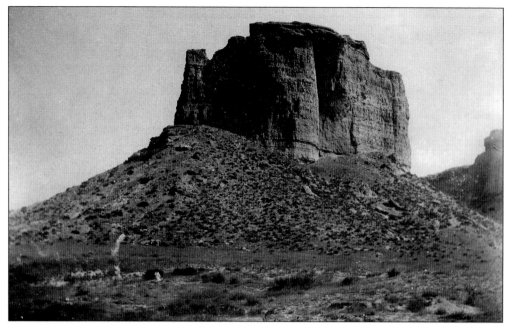

A well-known landmark between Chugwater and Wheatland is the Chimney Rock bluff on Chugwater Creek near Slater. Many Native American artifacts have been found in the area, along with a large site filled with bison bones. (Courtesy of Ruth Chase Irvine.)

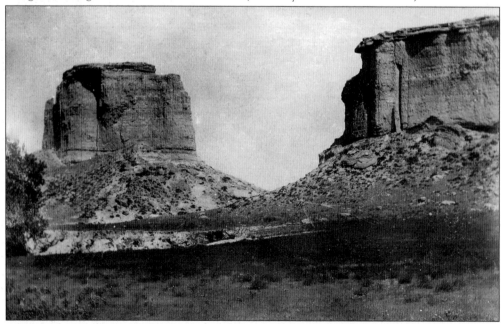

These steep bluffs above Chugwater Creek form a large mesa leading to the Chimney Rock formation. Legends say that Native Americans stampeded herds of buffalo over the bluff, resulting in the death of the animals as they landed along the creek below. The buffalo made a chugging sound as they hit the ground near the creek. Thus, it is said, the natives called the area, "place by the water where the buffalo chug." White settlers adopted the name Chugwater for the creek and a town a few miles to the south. (Courtesy of Ruth Chase Irvine.)

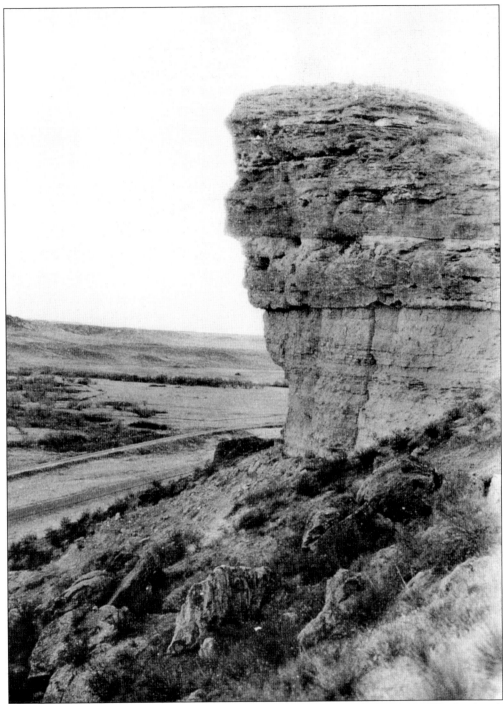

A long string of chalk-colored bluffs line the valley between Slater and Chugwater. This landmark just north of the town of Chugwater was well known, because it looked like the head and face of a person. Part of the face was removed when the route for Interstate 25 was carved through the area in the 1960s. (Courtesy of Ruth Chase Irvine.)

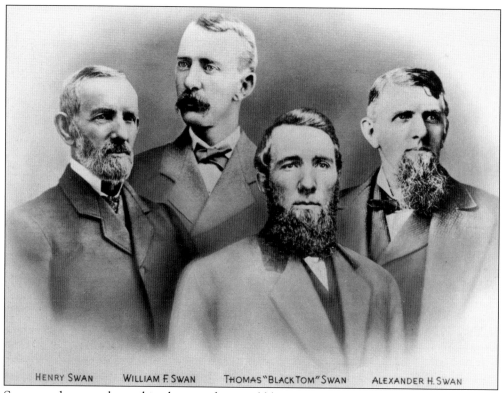

HENRY SWAN WILLIAM F. SWAN THOMAS "BLACK TOM" SWAN ALEXANDER H. SWAN

Some ranches were located in the area that would become southern Platte County in the late 1800s. The history of the Swan Land and Cattle Company is long and tangled. This photograph shows the Swan brothers, from left to right, Henry, William, Thomas, and Alexander. Henry, Thomas, and Alexander moved to Wyoming in the 1870s. Alexander and Thomas formed the Swan Land and Cattle Company. (Courtesy of the Wyoming State Archives, Department of State Parks and Cultural Resources.)

Alexander and Thomas Swan created an empire with some of the best land in the territory by 1883. Alexander went to Edinburgh, Scotland, to secure financial support, and he managed the company from 1883 to 1888. The company claimed to own 100,000 head of cattle ranging on millions of acres from Ogallala, Nebraska, to Rawlins, Wyoming. The disastrous winter of 1886–1887 resulted in huge cattle losses (whose original numbers were inflated) and led to the end of Alexander's term as manager. (Courtesy of LaDawna Friesen.)

Swan Company buildings in Chugwater are shown in 1924. The building in the foreground was the office, bunkhouse, and company store, which contained groceries, hardware, and more. The other building, known as the White House, became the manager's home after 1888. It had previously served as a hotel on the Cheyenne-to-Deadwood Stage Route. John Clay and Alexander Bowie were managers before Curtis Templin took over in 1915, and he lived in the White House until his death in 1968. (Courtesy of the Chugwater Museum.)

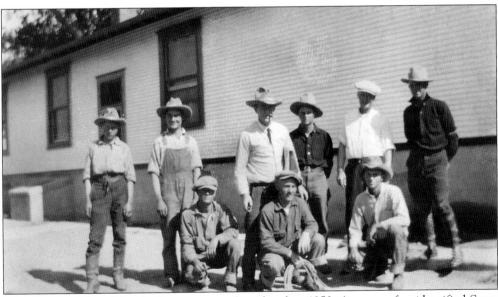

The Swan Land and Cattle Company was liquidated in 1950. A group of unidentified Swan Company cowboys are shown in front of the bunkhouse around 1920. According to Russell Staats, a longtime employee of the company, there were around 75 employees on different ranches in the winter with around 200 employees during the summer months. Salaries for ranch hands during the 1930s averaged $30 a month, but when times were good, the salary might rise to $50 a month including room and board. (Courtesy of the Chugwater Museum.)

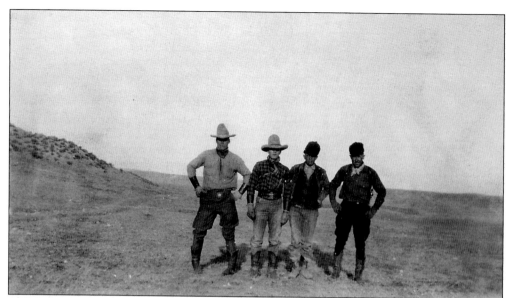

A few of the Swan Company cowboys pictured here in 1920 are, from left to right, Bob McConnel, Irving McConnel, Bob Morey, and Marion Woolf. (Courtesy of the Chugwater Museum.)

Portugee Phillips, Thomas Maxwell, and Hiram "Hi" Kelly were among the first ranchers to locate on the broad meadows along Chugwater Creek. All three men recognized the importance of the stage lines passing through and built two hotels, one owned by Phillips and the other owned by Kelly and Maxwell. Hi Kelly came to Wyoming around 1860. He worked as a freighter and stage driver before settling on this ranch along Chugwater Creek in 1864. (Courtesy of the J. E. Stimson Collection, Wyoming State Archives, Department of State Parks and Cultural Resources.)

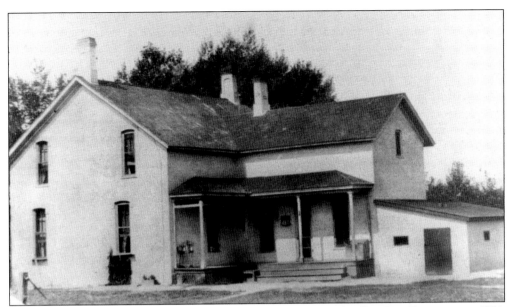

Hi Kelly married Elizabeth Richeau (sometimes referred to as Richard) at Fort Fetterman in 1864. Elizabeth was the daughter of French trapper John Peter Richeau and his full-blooded Sioux wife. Kelly built a 14-room brick mansion that became the center of social activity at the Chugwater ranch. He sold out to the Swan Land and Cattle Company in 1884 and moved to Cheyenne, where he built an equally grand home on Carey Avenue. The Chugwater mansion became a home for various Swan Company foremen and their families. The house and some of the land later formed a family ranch, and the house was torn down in 1974. (Courtesy of the Chugwater Museum.)

Hi and Elizabeth Kelly raised eight children: Kate, Cora, Clara, Chug, Will, Charles, Ben, and Jack. Hi Kelly was very handsome, with curly black hair and a long black beard. He stood 6 feet, 2 inches tall and had piercing blue eyes. Elizabeth was a talented artist and gardener. Hi and Elizabeth lived in Cheyenne for 18 years and then moved to Colorado. Elizabeth died in 1922, and Hi died in 1924. (Courtesy of the Chugwater Museum.)

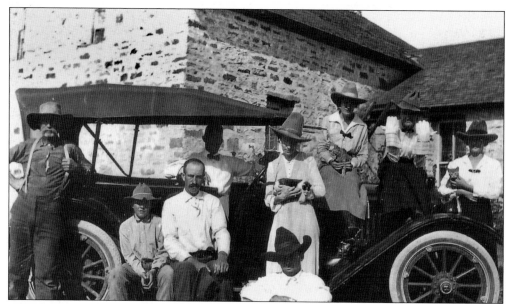

Other ranches were established about the same time as the Swan Land and Cattle Company. Donald McDonald emigrated from Scotland to Canada in 1869 and came to Wyoming territory in 1876. He formed the McDonald Ranch southwest of Chugwater in 1881 and married Jane Cameron. McDonald and his children are shown in 1915 in front of the rock house built in 1890; from left to right in the first row are Donald, Duncan, Robert, and Hugh (with large black hat). Margaret is standing behind Hugh, and the others are unidentified. (Courtesy of Lindy Schroeder.)

After his parents retired and following the death of Duncan in 1918 and Robert in 1921, Hugh McDonald took over the south portion of the ranch. Margaret and her husband ran the north portion. Hugh married Rissa McCann in 1922. Rissa, no ordinary woman, could outwork most men. She was a good carpenter, built fences, and stacked hay in addition to keeping house and cooking. She is at left in black hat driving a buggy with an unidentified relative. (Courtesy of Lindy Schroeder.)

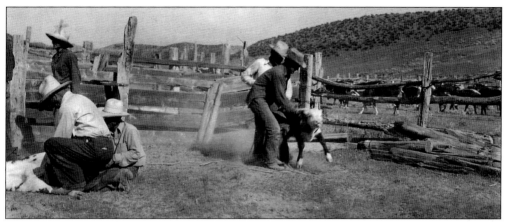

Hugh and Rissa McDonald's quadruplets, born prematurely in 1924, died shortly after birth. Their daughter, Ruth, born in 1927, became her father's constant companion and top hand. One day, when Hugh was taking a nap after lunch, Ruth tied two green ribbons in his hair. After his nap, Hugh grabbed his weathered hat and joined several cowhands working cattle by horseback. One cow tried to cut back on Hugh, and he took after her on a high lope. His hat flew off, leaving two exposed green ribbons blowing in the wind, and the cowboys howled with laughter. Hugh is kneeling on the left, with Ruth standing behind him wearing a white hat, in this branding photograph. (Courtesy of Lindy Schroeder.)

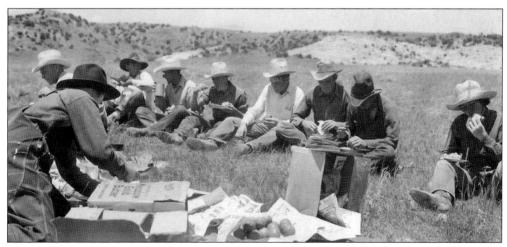

Rissa McDonald prepared lunch to be brought to the pasture on branding day. She is shown at left around 1939 in her traditional overalls cutting a pie for the workers, who are unidentified. Ruth McDonald is on the far right. (Courtesy of Lindy Schroeder.)

Since Ruth McDonald was an only child, she grew up pretty much by herself. She became an accomplished horsewoman, and her best friend was her pony. She sometimes rode over to visit the nearest neighbor children, 3 miles from the home ranch. (Courtesy of Lindy Schroeder.)

When Ruth was six years old, a schoolhouse was moved to the ranch about a quarter-mile from the house. The teacher lived with the McDonalds, received a salary of $80 a month, and paid $30 a month for her room and board, which was a common custom for rural schools. Ruth seldom had classmates and rode her horse to school so she could play games with the horse during recess. Ruth and the teacher traveled to nearby schools for spelling bees and other events. Ruth attended Chugwater High School, the Grand Island Business College, and the University of Wyoming. She married John Braunschweig in 1949. (Courtesy of Lindy Schroeder.)

George Rainsford founded the Diamond Ranch 12 miles west of Chugwater. He raised Thoroughbreds branded with a small diamond, inspiring the ranch's name. Rainsford built several large stone stables like this one. He also lived in Cheyenne and designed many homes still seen in the Rainsford Historic District there. He turned the Diamond Ranch over to Maj. Paul Raborg, who raised polo ponies; then David and Dora Oberman operated the Diamond as a cattle ranch; and in 1956, a portion of the land was sold to Hugh and Rissa McDonald. (Courtesy of Lindy Schroeder.)

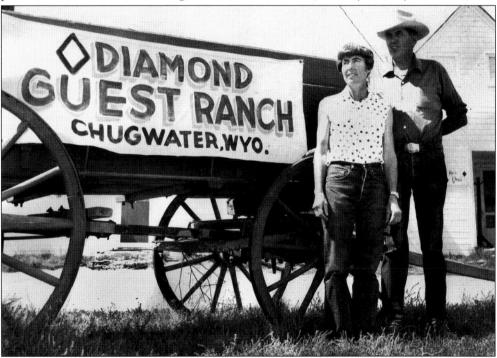

The McDonalds leased the headquarters to the Methodist Church camp until 1965. John and Ruth Braunschweig and their daughters Cindy, Lindy, and Valorie moved to part of the Diamond, the LL Ranch, in 1961. The Braunschweigs later remodeled the headquarters buildings as a guest ranch. Ruth and John are shown at the July 1968 grand opening of the Diamond Guest Ranch, which they operated until 1980. Others managed the guest ranch until 2005, when it reverted to a working ranch. (Courtesy of Lindy Schroeder.)

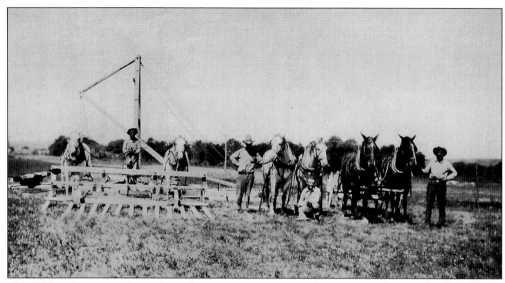

Up until 1908, Chugwater was known as cow country, and the land was not considered suitable for farming. However, around 1908, homesteaders began to move into the area, and they established dryland farms mostly to the east of Chugwater, in the areas that came to be known as the Chugwater Flats and the Iowa Flats. They grew mostly wheat, oats, and hay. This photograph shows an unidentified group of early farmers harvesting hay near Chugwater. (Courtesy of the Chugwater Museum.)

Several Jewish farmers settled on the flats east and north of Chugwater from 1908 to around 1920. This photograph shows a group of Jewish farmers around 1918. Julius Bredy is on the horse, and the woman is Dora Greenspoon Massion holding her son, Ely, with her daughter, Amelia, standing in front. (Courtesy of Andrea Massion.)

Many farmers and ranchers raised sheep. Independent contractors went from ranch to ranch during June and sheared the sheep, with each man shearing an average of 120 sheep a day. The wool was thrown into large sacks, which workers tamped tightly. Bags of wool like the ones on this wagon were hauled to the railroad to be shipped for processing. (Courtesy of the Chugwater Museum.)

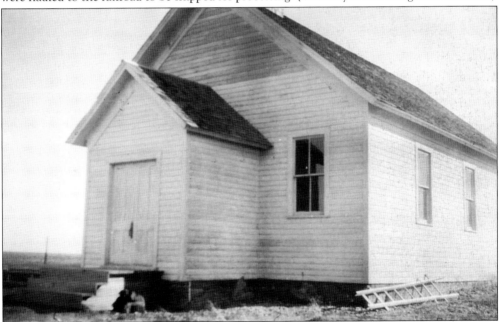

By 1910, the flats east of Chugwater were home to around 500 people, and a Methodist church and cemetery were built. In May 1911, a late spring blizzard raged for three days and nights. Minnie Warren and her two-year-old daughter, Opal, had attempted to walk to Minnie's parents' farm and became lost in the blinding snow. They were found frozen to death about 6 miles from their home and were the first two burials in the cemetery. The Methodists eventually built a church in Chugwater and no longer hold services on the flats. The Chugwater Cemetery District now manages the property. (Courtesy of Lindy Schroeder.)

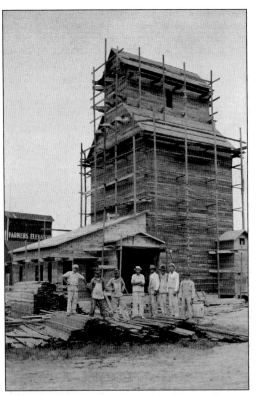

On August 7, 1912, twenty-one homesteaders met in the Methodist church east of Chugwater to organize a farmers' cooperative association to handle and sell the crops raised in the community. Near the end of 1912, the group had erected a small building and weighing scale in Chugwater. Though the group struggled for a few years, other farmers joined, and they were able to construct a new grain elevator, shown in this photograph, in 1914. (Courtesy of the Chugwater Museum.)

After several managers had a difficult time running the farmers' cooperative, Archie Blow took over in 1920 and served as manager until 1934. Blow owned a farm on the Chugwater Flats and had previous experience operating a creamery in Iowa. He had also purchased a tractor and threshing machine and did custom threshing for local farmers. During Blow's tenure at the co-op, the complex was expanded to include a general store, meat market, filling station, garage, and flour and feed mill. (Courtesy of the Chugwater Museum.)

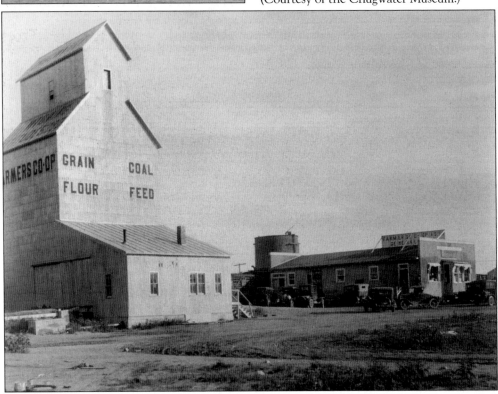

By the late 1920s and the 1930s, the farmers' co-op had grown into a business that met most of the homesteaders' farming and household needs. A large crowd is gathered in front of the co-op for an unknown occasion in this photograph. (Courtesy of John Voight.)

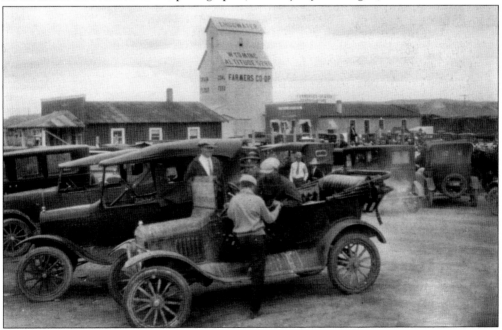

Farmers and their families have gathered for some sort of meeting or celebration in this photograph at the farmers' co-op in Chugwater in the 1920s or 1930s. Notice the painting on the top of the grain elevator showing the altitude of 5,280 feet. (Courtesy of John Voight.)

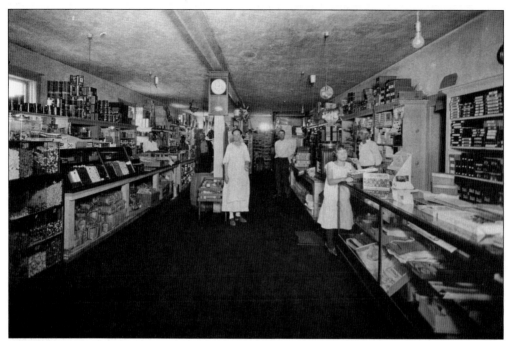

The shelves are well stocked in this interior photograph of the farmers' co-op grocery store. The business flourished well into the mid-20th century, though it closed after Interstate 25 was built and people found it handier to travel to Wheatland or Cheyenne to obtain supplies. The property languished for years, was briefly turned into a restaurant, was empty until 2008, and is now the home of the Stampede Steakhouse. (Courtesy of the Platte County Library.)

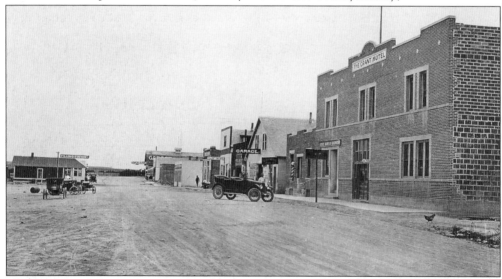

Though the original plat for Chugwater was filed in 1887, the town did not really begin to grow until a new plat was filed in 1914. New businesses opened in the town advertised as the "Gateway to Platte County's Great Dry Farming District." The Grant Hotel, shown in this photograph, was one of the new landmarks, and there was also the Hart Hotel. The town's first newspaper, the *Chugwater Record*, began in 1914 but moved to Wheatland in 1927. The *Chugwater News* was published from 1928 to 1952. (Courtesy of Ruth Chase Irvine.)

The Chugwater Valley Bank was chartered in 1913, and this building was erected in 1918. Russell Staats came to Chugwater as a cashier for the bank in 1922; he served for more than four years before becoming the cashier at the Swan Land and Cattle Company. Staats was elected Chugwater mayor in 1934, and except for one term, he remained in office until 1985. Fred Cashner assumed the bank cashier's job in 1927 and served until his retirement in 1964. The bank closed for a time, housed the Chugwater Museum briefly, and is now the Oregon Trail Bank. (Courtesy of the Chugwater Museum.)

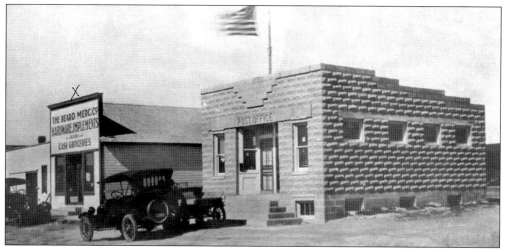

Richard Whalen, a local rancher, operated the first post office in the Chugwater area in 1886 and called the town Chug Water (two words). It was not until 1896 that the post office, under postmaster Frank Foss, recognized the name Chugwater as a single word. This photograph of the Chugwater Post Office was taken around 1916, when Arthur Bastian was postmaster. (Courtesy of the Platte County Library.)

Chugwater flourished during the mid-20th century with businesses like this Conoco station. Locals and tourists kept gas stations and restaurants busy. Harvest crews, highway construction crews, and workers who built the nearby missile sites brought additional business to Chugwater. Following that era, business began to decline, and many of the buildings were vacated. In recent years, new enterprises, including the Chugwater Chili Corporation, have opened. The Chugwater School continues to be a center for activity, as it has been for more than 75 years. (Courtesy of the Platte County Library.)

E. M. Hedges built the Texaco station at the corner of First and Clay Streets in 1928. His son, Wendell, operated the business from 1950 to 1963, and his grandson, Tom, ran it until 1965. General merchandise was sold there along with hunting and fishing licenses, hardware, and small appliances. Hedges also sold Desoto and Plymouth cars until 1941 and John Deere products and farm equipment until 1950. The business was leased from 1965 to 1975, and the building was demolished in 1976. (Courtesy of the Chugwater Museum.)

This building, constructed in 1914, housed a drugstore and soda fountain. It was originally a doctor's office and pharmacy, with a small apartment in the back for the doctor and his family. The soda fountain's back bar was built in England and was first installed elsewhere then moved to Chugwater in 1927. Snyder's Drug Store is shown in the 1940s. The pharmacy and soda fountain coexisted for some time but eventually became only a soda fountain. Ownership has changed hands many times, but the Chugwater Soda Fountain is considered to be the oldest continuously operating soda fountain in Wyoming. (Courtesy of the Chugwater Museum.)

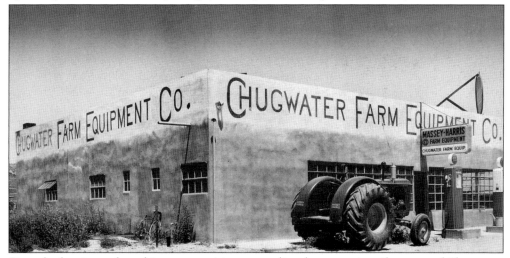

Since the farming and ranching communities surrounding the town primarily supported Chugwater, the sale of farm implements was important. The Chugwater Farm Equipment Company is shown in this photograph. There were also additional grain storage facilities operated by the Tri County Grain Company, which was founded by Herman Hellbaum. (Courtesy of the Chugwater Museum.)

During the 1960s, several Atlas missile installations were built throughout southeastern Wyoming. The Chugwater community held several of these underground missile silos. Some of the sites were decommissioned in 1965 and offered for sale. (Courtesy of the Platte County Library.)

Francis Daellenbach purchased one of the missile silos south of Chugwater in the 1960s. He lived there and operated a machine shop for 40 years. (Courtesy of the Platte County Library.)

This photograph shows Francis Daellenbach's dog posing on top of a building at the old missile site. (Courtesy of the Platte County Library.)

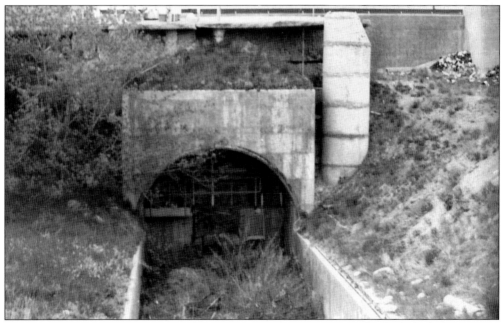

The entrance to the silo is shown in this photograph. After Francis Daellenbach died, the property was again offered for sale and was purchased by Frontier Astronautics. (Courtesy of the Platte County Library.)

Wyoming is called the cowboy state with good reason. A Platte County ranch near Chugwater was home to Harold Piper, shown in 1944 on board the horse Eagles Nest at Cheyenne Frontier Days. Piper rodeoed most of his life, riding in rodeos all over the United States and Canada, including Calgary, at Cheyenne Frontier Days, and at Madison Square Garden. The *Denver Post* awarded him a pair of silver spurs and the title "Hard Luck Cowboy of Cheyenne Frontier Days" in the 1950s. (Courtesy of Regina Bradford.)

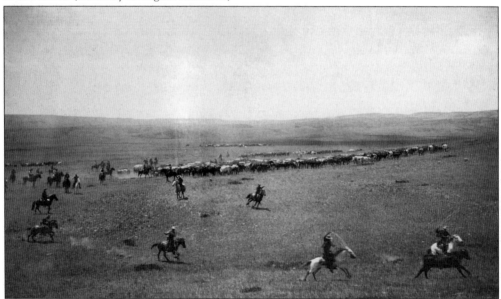

This late 1800s photograph shows cowboys riding the open range in southern Wyoming with wild abandon. Those days are forever over, but the wide-open spaces of Wyoming remain and spark the imagination of many a would-be cowboy or cowgirl. Even today, roundups are sometimes held, brandings continue to unite families and neighbors when they gather to help each other, and a lone cowboy can sometimes be seen riding over the windswept prairie. (Courtesy of Fred and Mickey McGuire.)

One of Wyoming's most beloved characters is a horse that was born on this Frank Foss ranch west of Chugwater in 1896. In 1899, Foss sold the horse to the Swan Land and Cattle Company, whose cowboys tried unsuccessfully to break him to ride. When the hands on the Swan Company's Two Bar Ranch castrated the horse, he hit his head on the ground and broke his nose. The cowboys dubbed him Steamboat because, as a result of the accident, he breathed with a whistling sound. Steamboat could not be tamed and was sold as a rodeo horse. (Courtesy of the Chugwater Museum.)

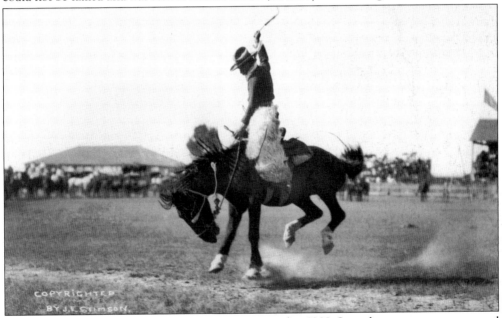

Steamboat, Wyoming's famed bucking horse, is pictured in 1908. Steamboat was never conquered by any of the cowboys who tried to ride him, according to legend. It is widely accepted that Steamboat is the bucking horse pictured on the Wyoming license plate, although the name of the cowboy is uncertain. Steamboat symbolizes the determined spirit of the people of Platte County and Wyoming. (Courtesy of the J. E. Stimson Collection, Wyoming State Archives, Department of State Parks and Cultural Resources.)

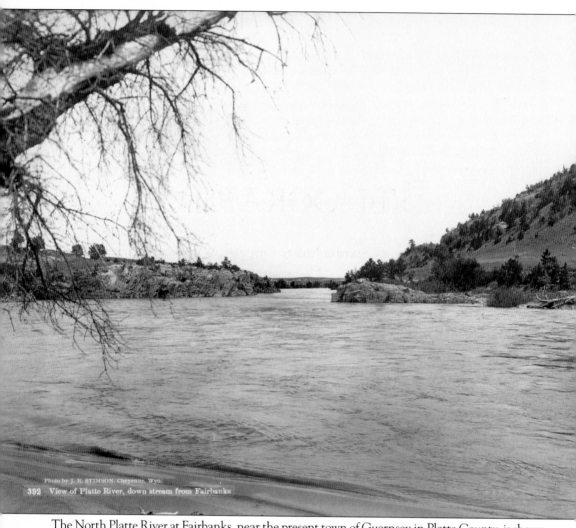

392 View of Platte River, down stream from Fairbanks

The North Platte River at Fairbanks, near the present town of Guernsey in Platte County, is shown in this photograph. The North Platte River originates in northern Colorado, meanders through Wyoming, joins the South Platte River in western Nebraska, and flows into the Missouri River near Omaha, Nebraska. The river remains a significant source of water for many uses. It served as an important transportation route in the westward expansion of the United States, providing the route of several of the major migration trails, including the Oregon Trail and the Mormon Trail. (Courtesy of the J. E. Stimson Collection, Wyoming State Archives, Department of State Parks and Cultural Resources.)

BIBLIOGRAPHY

Hodgson, Donald. *Chugwater, a Centennial History.* Cheyenne, WY: Wyoming State Historical Preservation Office, 1986.

Larson, T. A. *History of Wyoming.* Lincoln, NE: University of Nebraska Press, 1978.

Moulton, Candy. *Roadside History of Wyoming.* Missoula, MT: Mountain Press Publishing Company, 1995.

Moulton, Candy Vyvey, and Flossie Moulton. *Steamboat: Legendary Bucking Horse.* Glendo, WY: High Plains Press, 1992.

Platte County Extension Homemakers Council. *Platte County Heritage.* Wheatland, WY: Platte County Extension Homemakers Council, 1981.

Trenholm, Virginia Cole. *Footprints on the Frontier.* Douglas, WY: Douglas Enterprise, 1945.

Woods, Lawrence M. *Alex Swan and the Swan Companies.* Norman, OK: Arthur H. Clark Company, 2006.

ACROSS AMERICA, PEOPLE ARE DISCOVERING SOMETHING WONDERFUL. THEIR HERITAGE.

Arcadia Publishing is the leading local history publisher in the United States. With more than 5,000 titles in print and hundreds of new titles released every year, Arcadia has extensive specialized experience chronicling the history of communities and celebrating America's hidden stories, bringing to life the people, places, and events from the past. To discover the history of other communities across the nation, please visit:

www.arcadiapublishing.com

Customized search tools allow you to find regional history books about the town where you grew up, the cities where your friends and family live, the town where your parents met, or even that retirement spot you've been dreaming about.